LEGENDARY LOCALS

OF

LAKEWOOD

WASHINGTON

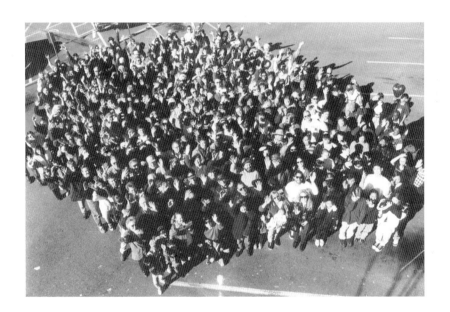

D1601910

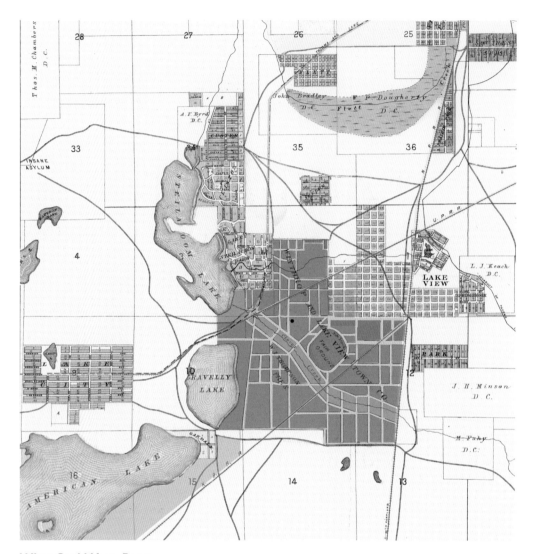

What Could Have Been
This section of an 1891 map of what was then considered the rural outskirts of Tacoma shows the master plan of Walter Thompson (see page 17). His vision was stymied when he, like so many others, lost a fortune in the Great Panic of 1893. The Puyallup Fairgrounds did not come along until 1900. If Thompson's vision had been built, the state fairgrounds might be located in Lakewood today, roughly where Tyee Park Elementary School stands. Instead, Thompson's 1,800 acres of land holdings were reduced to 10, though he still used those to become an early Lakewood developer as the economy recovered. (Courtesy of the MASC, Washington State University Libraries.)

Page 1: Our Citizens
In 1996, the editor of the *Lakewood Journal*, Walter Neary, and reporter and future editor Steve Dunkelberger, decided to illustrate a special section about the new city with a "group portrait." They put out a call for people to show up in the Lakewood Mall parking lot on one morning, and people did. Also present was a large cardboard cutout of John Wayne. Deb Pastner took the photograph from a cherry picker. (Courtesy of Steve Dunkelberger.)

LEGENDARY LOCALS

OF

LAKEWOOD

WASHINGTON

STEVE DUNKELBERGER AND WALTER NEARY

LEGENDARY
LOCALS

Legendary Locals is an imprint of Arcadia Publishing
Charleston, South Carolina

Printed in the United States of America

Library of Congress Control Number: 2013944358

For all general information, please contact Arcadia Publishing:
Telephone 843-853-2070
Fax 843-853-0044
E-mail sales@arcadiapublishing.com
For customer service and orders:
Toll-Free 1-888-313-2665

Visit us on the Internet at www.arcadiapublishing.com

Dedication
To the greatest of Lakewood legends: Tina Griswold, Ron Owens, Mark Renninger, and Greg Richards.

On the Front Cover: Clockwise from top left:
The "Fallen Four," Sgt. Mark Renninger and Officers Tina Griswold, Ronnie Owens, and Greg Richards (courtesy of Lakewood Police Department; see page 103), H.F. Alexander and Joseph Carman III (courtesy of Joseph Carman IV; see page 38), City clerk Alice Bush and veteran Robert H. Benton Jr. (courtesy of Alice Bush; see page 89), Ivan the Gorilla (courtesy of Tacoma Public Library; see page 122), Tacoma Speedway racers (courtesy of Tacoma Public Library; see page 116), the legs of Joseph Carman III and Dorothy Alexander (courtesy of Joseph Carman IV; see page 38), disc golf pioneer Ray Seick (photograph by Steve Dunkelberger; see page 75), the Irwin family (courtesy of Tacoma Public Library; see page 47), Mayor Claudia Thomas (courtesy of City of Lakewood; see page 92).

On the Back Cover: From left to right:
Gary and Carol Milgard (courtesy of Milgard Foundation; see page 74), George Weyerhaeuser, George H. Weyerhaeuser Jr., Corydon Weyerhaeuser, and Walker Weyerhaeuser (photograph by Sarah Weyerhaeuser; courtesy of Kathy McGoldrick; see page 72).

CONTENTS

ACKNOWLEDGMENTS

We are grateful for the hard work of historians Gary Reese and Cyrus Happy, who kept the faith of Lakewood history before there was a city. We will thank others in reverse alphabetical order, so we begin with Lakewood assistant police chief Mike Zaro, who helped over and over with questions about a painful memory for everyone. We also thank Erin Vosgien, our Arcadia Publishing editor, as patient as she is sharp; Steve Thompson, who has rightful pride in pioneer ancestors; Greg Rediske, for gathering the history of the Lakewood Rotary; Ed Kane, a photographer who published a newspaper in Lakewood and has collected thousands of photographs of the period 2003–2005; Capt. Michelle M. Johnson at West Pierce Fire & Rescue; Joseph Carman IV; Jeff Brewster; Kathleen Benoun; and Steve Anderson. We also appreciate the fine folks at the Northwest Room of the Tacoma Public Library and the Washington State Historical Society. Others we thank for boosts along the way are the Historic Fort Steilacoom Association, Lakewood Historical Society, Ben Sclair and the *Suburban Times*, Stephen Neufeld, the Jini Dellaccio Collection for its wonderful assistance in documenting local rock history, and Lakewood Playhouse's John Munn.

INTRODUCTION

This book represents the second effort by Walter Neary and Steve Dunkelberger to capture a part of Lakewood's remarkable people and history. Our first Images of America book, 2005's *Lakewood,* was oddly prophetic about the future of Lakewood, but not entirely in a way intended or wanted. The authors chose to close that book with a photograph of the brand-new Lakewood Police Department, as they felt the development of the police force was a major part of the city's history. Indeed, it has been. Crime rates are down, and people feel pride in "their" department.

But history comes along and overturns expectations. Of the faces in that photograph, four were involved in the most awful event in Lakewood's history. Within about 60 seconds on the morning of November 29, 2009, an ex-con with mental problems entered a coffee shop just outside the city limits and fatally shot four Lakewood officers. The assailant had absolutely no connection to Lakewood. He just wanted to kill people in uniform. The officers in front of him happened to be from Lakewood.

A place as comforting as a coffee shop, where friends meet to catch up on the day, was turned into a horrific crime scene. Individuals, families, and groups from around the world sent messages and prayers. The world grieved for Lakewood.

No history book of Lakewood can now be complete without reference to these senseless killings. As this Arcadia series is about legendary locals, we knew we needed to compile another publication. In this second book, we have tried to capture a cross-section of other amazing and accomplished people in our community. While the killing of the police officers was an awful event, there were many more things that happened that make one's heart burst with pride. For example, in 2006, the city produced the first African American female mayor of a Washington city, Claudia Thomas. In many ways, this was an expiation of the city's past; one doesn't have to look through many historic photographs before realizing that Lakewood before the middle of the 20th century was pretty Anglo.

Sometimes, the story of a legend becomes so overwhelming that one has to include the legend, even when it is an odd match. So it goes with one of the legends chronicled here. Ivan the Gorilla lived in suburban-mall captivity for 27 years before pressure from around the world led to his transfer to the gorilla habitat at Zoo Atlanta. We pondered not including Ivan, since he was covered in the first book. But, in 2013, a book inspired by him, *The One and Only Ivan,* by Katherine Applegate, won the most prestigious award for children's' fiction, the Newberry Medal. In his own way, Ivan is a lasting legend of the community, with lessons to teach for a long time to come.

That brings up another point. We did not attempt to include subjects that were covered in the first book, such as the long and fascinating history of Western State Hospital. This latest book includes such obvious choices as the Lakewood Four and Claudia Thomas, but many other choices came about because of the availability of photographs and circumstance as well as the experiences of the authors. We ran notices in the *Suburban Times* asking for photographs. So, in that sense, we tried. But there is never enough time to chase all ideas. We stand by our choices of what to include, but also understand that many wonderful people who changed Lakewood and beyond for the better are not in this book. If someone reading this book is a family member or even one of those community builders, we apologize for that. Hopefully there will be a third book, and as more and better photographs are discovered, a fourth.

So we thank you for showing interest in Lakewood history and the people who made the city what it is today. The purpose of this book is to highlight the people, rather than the institutions, since, ultimately, a community is its people. In a city of Lakewood's size and span of development, the roster of notables is quite lengthy. This book is by no means a comprehensive who's who of them. It is a sample. The book is meant to provide readers with a sense of the people of its past in a way that illustrates Lakewood's

character. They left their footprints on the soil, but so very many others did as well. Mentioned or not, thousands of people did their share to make Lakewood what it is today. They often quietly did their community work out of a sense of duty, a sense of service, or in pursuit of a better life for themselves and their families. Many of their names have simply been lost to history, but further research is under way. New names are added to the "notables" roster because the city continues to grow and change and improve. The parade of footprints left by volunteers and visionaries will continue to be made as long as there is a Lakewood. It is part of the community's character. Lakewoodians take charge and bring change. They make something from nothing by rolling up their sleeves, gathering neighbors, and bringing the change they seek. It is to honor these people—past, present, and future—that drove this project.

A final note: we maintain a website, www.lakewoodhistory.tumblr.com, which we will update with links to the important historical societies of Lakewood and news about images in this book. What errors we made, we will try to correct there. Please visit us at the site.

CHAPTER ONE

First and Fearless

The Pioneers

The story of America can be told in the story of Lakewood. The community that was first open prairies and hunting grounds of Native Americans became farmland as settlers moved west. The region grew, becoming a recreational center for Tacoma as "the Lakes District," then a community with its own character. The pioneering spirit to find a new life shifted, and settlers sought to put down roots and improve their lives by improving their homes.

The first non-native settlers waved a British flag, swearing allegiance to the nearby Hudson's Bay Company (HBC) post of Fort Nisqually, in what is nearby DuPont. The first Fort Nisqually was established in 1833 in an effort to gather firs and local goods and to serve as a safe port for trips around the Pacific.

The first notable settler was Joseph Heath, who had come to the Puget Sound country in early 1844 to try to recoup a fortune he had lost in England. He leased a square mile of land from the Hudson's Bay Company, which held leases on farms that Red River Settlement pioneers had leased in 1841, only to abandon them two years later. Heath planted about 30 acres of a former Red River Settlement farm and used the rest of the prairie land for grazing cattle and sheep. His diary laments the rocky soil and the solitude he faced as a gentleman farmer on the frontier, which was rapidly being lost to American settlers rather than won by British business interests. Heath wrote in his entry for January 17, 1845: "Making out a requisition for things from Fort Vancouver for the ensuing year. My brain is much puzzled; constantly think out what will be necessary. Came indoors twenty times today to put down things that struck in my mind."

Heath seemed relieved when he got another neighbor of Anglo heritage, John McLeod, a longtime employee of the HBC. He even had a family. McLeod had been born to a herdsman's life in 1815 on an island in the northern Hebrides of Scotland. He had a reputation for hard work and careful tending of animals. A fight took place in 1837 involving McLeod, his whiskey still, and a man who McLeod mistakenly thought was a taxman. The man fell into the still's fire, and McLeod thought he'd killed him. He fled to Canada in 1837 and went to work for the HBC. He was put to work chopping wood to feed the steamer *Beaver,* which at one point carried anyone who was anyone on the waters of Puget Sound. The HBC encouraged its men to marry Native American women, to pursue good relations wherever they settled. McLeod had gone to the family of S'Ka-ná-wuh, who the Anglos called Mary, and proposed. She had the flattened forehead indicating aristocratic status among the natives. She was the daughter of a Cowlitz man who the Europeans called a chief. It was a very small world back then; Mary's half-brother as well as a cousin worked for Joseph Heath.

McLeod established Whyatchie Farm, which was centered roughly in the area of today's Lakewood Library toward Steilacoom Lake, south of Ponce de Leon Creek and northwest of what is now Clover Park High School. He managed sheep and other livestock for the HBC. According to historian Steve Anderson, McLeod's territory included part of what is now University Place and the Meadow Park, Oakbrook, and Steilacoom golf courses, across the Puyallup plain that took in much of present-day Tacoma, up to the ridge that overlooks the present-day Puyallup tribal businesses.

Heath meanwhile decided to return to England when a boundary discussion between America and England put his land on the wrong side of the border. But he died on March 7, 1849, before he could leave. The brutal truth seems to have been that his family had no interest in visiting him and did not send him medications he had requested. One of his last diary entries states, "Constantly grieving to think that I am forgotten by nearly all dear to me." His farm would later be leased to the federal government for the establishment of Fort Steilacoom.

Other settlers would follow, but they would largely wave the Stars and Stripes. They included people from the Pacific islands who journeyed across the sea with English or American ships to work in unknown lands. They included Irish and German immigrants leaving their lives in Europe for adventure on the frontier. They were gentlemen from Boston and criminals on the lam from New York. They were all mixed together on the prairie lands of what is now Lakewood. Many locations around the city still bear their names.

One of the executors of Heath's will was Thomas Chambers, an American of Irish descent who settled at the mouth of what is now called Chamber's Creek. When he first arrived, Hudson's Bay Company representatives dutifully showed up and asked him to leave. Chambers responded in a kind tone that he had no plans to leave and showed them his gun. The British, with no interest in an international incident and recognizing the inevitable, became his friends. Needless to say, the incident made Chambers a hero among Americans. Another notable settler was Willis Boatman, who brought his family to the Washington Territory shortly after the area separated from its southern neighbor, Oregon, in 1853. They were one of only a few pioneer families to settle in the wilderness north of the Columbia River. Most of the other wagon-trainers headed for the Willamette Valley. The Puget Sound was nothing but wilderness and empty fields.

Boatman came to Steilacoom and worked in a lumber camp owned by town founder Lafayette Balch. The town incorporated in 1854 and served as a mediator of sorts between Native Americans and the rising tide of white settlers. Boatman's house remains to this day and is one of the oldest in Pierce County.

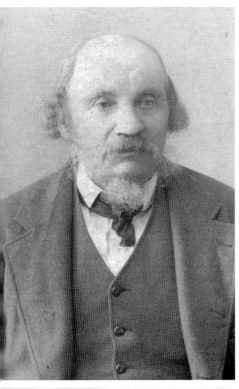

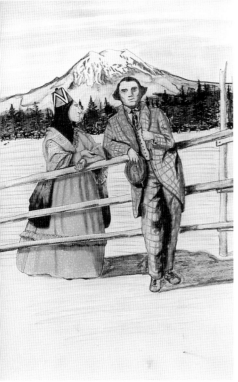

John McLeod

John McLeod is seen about 1880 (above) and in a modern drawing by historian Steve Anderson, depicting how McLeod and his wife, Mary, might have appeared on their farm. During tense times between American settlers and Native Americans in the mid-1850s, the imperious territorial governor, Isaac Stevens, who had taken the extreme step of declaring martial law, alleged that British settlers were not getting attacked and therefore must be traitors. It did not help that Native American leader Leschi had asked McLeod to be an intermediary with the authorities. McLeod had become an American citizen and was on his way to bringing oats and potatoes he had grown to the soldiers at Fort Steilacoom when civilians roughed him up and imprisoned him under charges of treason. Eventually freed, McLeod continued as a farmer and rancher until his death in 1905. Before his death, McLeod learned that the man involved in the whiskey still accident had actually survived. (Above, courtesy of Washington State Historical Society; below, drawing by Steve Anderson.)

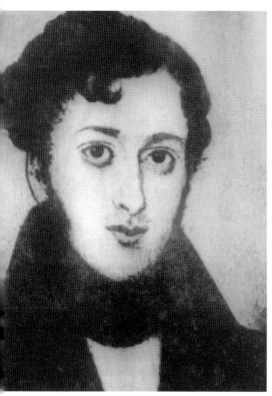

Joseph Heath

Among the challenges facing Joseph Heath, besides being a disgraced heir turned farmer, is that he had no clue how to manage the local Native Americans he needed to work on his farm. In his diary, he chronicles how he alternated between abuse, bribery, begging, and threatening. Historian Alexandra Harmon speculates that the Indians were probably equally puzzled by Heath: "those who bathed every morning would have been appalled that he went five months without a bath." (Courtesy of Washington State Historical Society.)

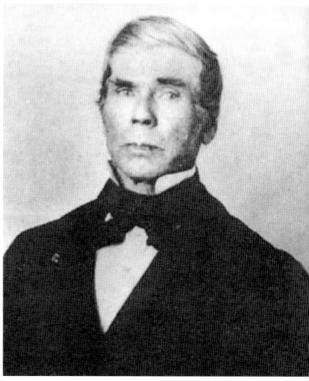

Thomas Chambers

Chambers became the area's probate judge. He was also an unusually dapper dresser. The story was told of a man freshly arrived at Steilacoom whose silk hat was quickly removed from his head and stomped on. The stomper, the man's brother, explained that there was no use for a silk hat out there and that, besides, only Judge Chambers was worthy of wearing a silk hat. (Courtesy of Historic Fort Steilacoom Association.)

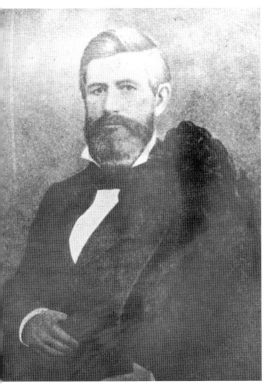

William Wallace

William Wallace moved to the Territory of Washington in 1853 and, within a few years, served as a member and then president of the territorial council. An attorney, he was brave enough to take on the case of Leschi (see page 25) despite community anger. He also was one of the handful of people his friend Abraham Lincoln had asked to accompany him to Ford's Theatre on a fateful night in 1865. Wallace instead became a pallbearer at Lincoln's funeral. After many other adventures, including service as the first territorial governor of Idaho, Wallace became Steilacoom's first mayor and served as a probate judge until his death in 1879. His remains lie within the grounds of Western State Hospital in a small cemetery that used to be part of Fort Steilacoom. His large tombstone lay toppled for some time, but the town of Steilacoom donated funds to have it repaired in August 2013. Below, Premier Memorial employees Randy Qualls (left) and Brad Perryman use steel rods and industrial-strength glue to return Wallace's monument to its grandeur. *News Tribune* photographer Dean J. Koepfler looks on. (Left, courtesy of Historic Fort Steilacoom Association; below, photograph by Walter Neary.)

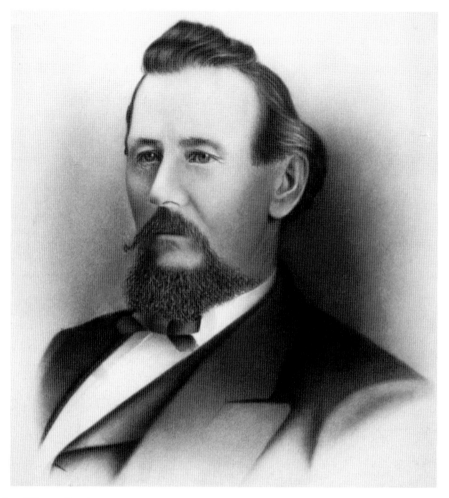

DeWitt Clinton Davisson

According to Pierce County historian Tim Farrell, Davisson was a Pierce County commissioner from 1867 to 1871 and Pierce County sheriff from 1871 until just before he died in 1874. Born in Ohio, Davisson left his family at 18 and traveled west to Indiana, where he was hired to drive an oxen train across the plains to Oregon Territory. The group arrived in central Oregon in 1853 and settled in what would become the town of Philomath. For a time, Davisson built homes for incoming pioneers in the Willamette Valley. He moved to Puget Sound, taking his first claim in what was then the middle of nowhere, the Hilltop of what would become Tacoma. He then bought land in present-day Lakewood and set up a furniture factory by Seeley Lake. After losing races for justice of the peace in Steilacoom and territorial representative, he became a county commissioner in 1867. A few years later, the sheriff of Pierce County, Isaac Carson, became an unpopular man when he tried to stop a lynching; the community responded by putting him in his own jail. Davisson challenged him in an election and won.

Davisson was able to secure additional funding from the legislature to improve the conditions of the Pierce County jail and the territorial jail, and he worked with other leaders to find a permanent solution to the need for a state penitentiary. Davisson was reelected in 1872 by a huge margin. He took ill in early 1874, and his family relocated to downtown Steilacoom. He chose not to run again, but maintained his office in the courthouse, still going in to work every day. Shortly after the November election to choose his replacement, Davisson passed away at age 42. His son, Ira, served as Tacoma city commissioner of utilities for 22 years starting in 1918. (Courtesy of Washington State Historical Society.)

Ezra Meeker

A pioneer trailblazer and business owner, Meeker is best known for his effort to preserve the Oregon Trail and his promotion of Pierce County's Puyallup Valley. In 1851, he married Eliza Jane Sumner. In April 1852, when their son, Marion, was only seven weeks old, they joined the westward trek from Ohio to the West Coast. They eventually settled in today's Puyallup. In 1855, when there was violence between Anglos and Native Americans, Meeker was among many whites who sought shelter at the US Army's Fort Steilacoom in Lakewood. The fort was designed for peace, not war, and it was not ready for the infusion of Anglos in the region. Meeker wrote that the scene was "a sorry mess . . . of women and children crying; some brutes of men cursing and swearing; oxen and cows bellowing, sheep bleating; dogs howling; children lost from their parents; wives from husbands; no order, in a word, the utmost disorder." At the age of 23, he served on the jury that first tried Native American leader Leschi (see page 25) on murder charges. The jury issued a hung verdict, which prompted Meeker to champion Leschi's innocence. Leschi was tried and convicted in a second trial. Meeker never forgot the hanging of a man he considered innocent, and his 1905 book about the matter was a savage indictment of Gov. Isaac Stevens and other authorities. Meeker went on to become the "hops king" of the Puyallup Valley, but didn't drink beer himself. At the time of his death in 1928 at the age of 97, he was beginning a trip in a Ford automobile with a covered wagon on the back to promote the Oregon Trail. It was a trip he had already made four times, garnering nationwide fame. He appealed to thousands of average Americans he met along the way, as well as celebrities like Presidents Theodore Roosevelt, Woodrow Wilson, and Calvin Coolidge, not to forget the Oregon Trail and its pioneers. (Courtesy of Historic Fort Steilacoom Association.)

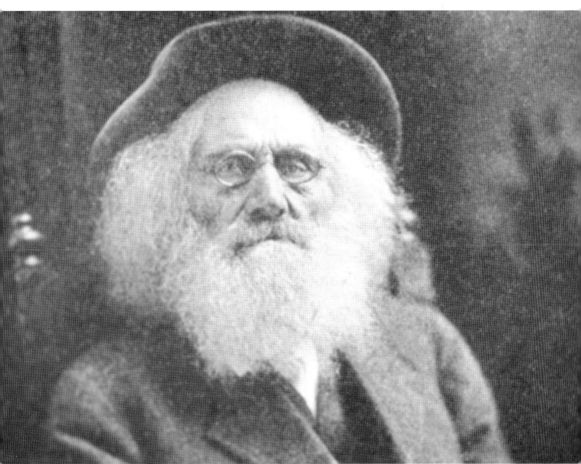

The Boatmans
Northwest pioneers Willis Boatman and his wife, Mary Ann, rode the Oregon Trail in their ox-drawn wagon in 1852 from Illinois and settled in the Puyallup area. However, the threat of attacks by Native Americans led them to seek shelter near Fort Steilacoom, just as Meeker had done. Boatman apparently liked the area and built a 24-foot-by-30-foot home near Gravelly Lake about 1858. It forms the kitchen and dining room of what is now the oldest surviving home in Lakewood. (Courtesy of Tacoma Public Library.)

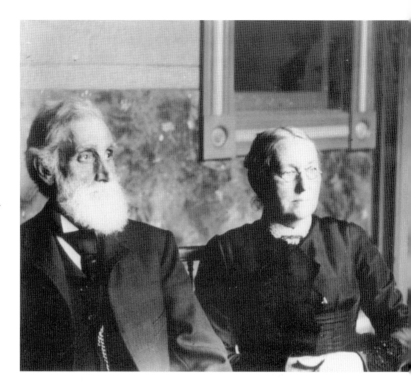

Alexander Baillie
Pioneer golfer Alexander Baillie was born in 1859 in Brechin, Angus, Scotland. He left Brechin at age 21 after graduating from the country's oldest college, University of St. Andrews, which is known as the birthplace of golf. Baillie immigrated to the United States to seek his fortune. He brought his golf clubs, and the rest is history. He was a founder of the first golf and country club in the region, Tacoma Country and Golf Club, after more than a dozen fellow Scotsmen at Tacoma's Balfour Guthrie Company needed something to remind them of home. At 35, Baillie was its first president.

In 1894, Baillie created the first golf course west of the Mississippi, a nine-hole course on 280 acres in what is now South Tacoma. It was only the fourth in the United States at that time. But the Tacoma location didn't last long. The course was moved in 1905 to its current location on American Lake to be closer to the estates of the well-to-do of the region. Members paid $250 to join the exclusive club. It was a place to make business deals, entertain dignitaries, and enjoy rounds of golf. Baillie died at his home on Gravelly Lake on September 7, 1949, just two days short of his 90th birthday and a year after the Tacoma Country and Golf Club held a banquet in his honor that drew 150 guests, in October 1948. (Courtesy of Tacoma Public Library.)

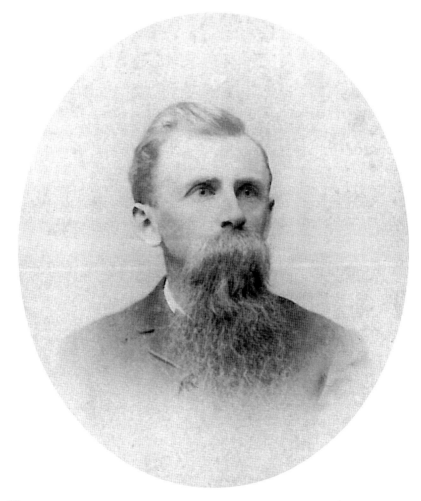

Walter Thompson

Walter J. Thompson's vision for Lakewood in 1891 is shown on page 2. It takes an audacious businessman to come up with a plan for 1,800 acres, and Thompson's business and political skills were as impressive as his beard. Thompson, who had been successful as a banker in Nebraska, bought the Bank of New Tacoma and renamed it the Merchants National Bank in 1884. He ran it as the largest bank in Tacoma, with a breathtaking capital available for investment of $250,000; banks typically had $100,000 available in capital. Thompson became one of the most powerful forces in Tacoma and, because of his reading and broad interests and his collections of art and books, his house was the gathering place of the city's intellectuals. Thompson donated money to promote women's suffrage, the establishment of the Tacoma Public Library, and vocational training within Tacoma public schools. While in the legislature, he helped win the vote for women in 1888, but the Washington State Supreme Court voided the law. It was the Panic of 1893 that set him back. In 1889, he had bought the oldest house in Lakewood, the Boatman home, to be closer to Olympia, where Thompson, who had once been a candidate for the US Senate, served in the legislature. It later became a base for him and his brother-in-law, Henry Drum, when fortunes reversed. Drum had been mayor of Tacoma in 1888–1889 and had been vice president of Merchants National. People noted that the two men were united by business and by Jessie Thompson, Drum's wife, but Thompson was a dedicated Republican, and Drum was a dedicated Democrat. They built their way back up in business in what was called "the Lakes District." Thompson sold Lakes District real estate, helping to settle Lakewood. (Courtesy of Stephen Thompson.)

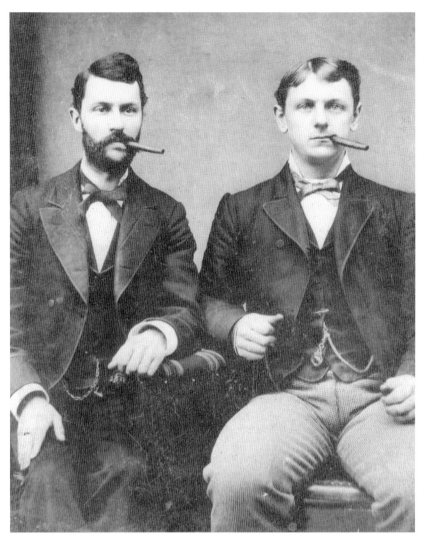

Charles A.E. Naubert and Frank C. Ross

Charles Naubert (left) and Frank Ross are seen here in their early 30s, around 1890, while actively developing the Tacoma & Lake City Railway (T&LC). The men offered lots in Lake City for $50 to $100, as well as a way to get to the area. The T&LC started at North Twenty-sixth Street and Union Avenue, ran south past what is now Snake Lake Park to Manitou, and from there to resorts at American Lake. Though the railroad only operated for seven years, it was instrumental in opening both the north end and the south end of Tacoma to development. Ross was 21 years old and penniless when he arrived in Tacoma in 1879. For pay, he worked first as a waiter, then shoveled gravel into mudholes, and later cut logs. At a fair in Chehalis, he made a quick $321 selling cigars, confectionery, California fruit, and imported newspapers. With the proceeds, he bought the southeast corner of Eleventh and Pacific in Tacoma and opened a real-estate office. He remained a developer for the rest of his life and was remarkably prescient about the future of Puget Sound trade, sending cigars to the parliament in Japan to encourage them to think well of the area and to do business with it. While Ross bragged that he never joined "secret societies," Naubert was a Mason for 50 years. Naubert had been a life insurance agent, a clothier, and even a farmer, on land that is now part of the Tacoma Country and Golf Club in Lakewood. Charles Naubert died in 1940, and Frank Ross died in 1947. (Courtesy of Tacoma Public Library.)

CHAPTER TWO

On Duty

Military Ties are Fused to Lakewood

During the westward expansion of the nation, the Army played a key role in providing expeditions, topographical surveys, frontier security, protection, and skills and services not available in pioneer settlements. The first military post in the Washington Territory was Fort Steilacoom, founded in 1849. It served the early pioneers until it was closed in 1869 to become what is now Western State Hospital.

In the mid-1800s, the Pacific Northwest was "disputed territory," being under the umbrella of the British Empire, which established trading posts in the region in the 1830s. The Hudson's Bay Company's Fort Nisqually, in present-day DuPont, was founded in 1833 and provided a foothold to the fur-trading and cattle-raising market along the West Coast. But American settlers were coming into the area in increasing numbers, creating a power struggle.

Fort Steilacoom marked a turning point in that struggle by acting as a formal military presence in the region. Not only did the fort provide a flow of federal greenbacks into the area in the form of contracts and payroll, but it also provided shelter for settlers during the Indian wars of 1854–1856. The fort was handed over to the state militia in 1861, when federal soldiers left to fight in the Civil War. The fort lowered its flag in 1869. While its presence helped the area grow, the big boost from military ties came decades later.

General Order No. 95, issued on July 18, 1917, declared the National Army Camp at American Lake to be named Camp Lewis, in honor of Capt. Meriwether Lewis, commander of the Corps of Discovery. The land had been donated by the residents of Pierce County, who voted to issue a bond to buy 70,000 acres of land and donate the prairie to the federal government for use as a military base. It remains the largest single gift to the federal government.

Camp Lewis, the largest military post in the United States at the time, opened in September 1917 and soon was home to more than 40,000 soldiers. Its first commander was Maj. Gen. Henry A. Greene, and it was home to the 91st Infantry Division before its deployment to France during the final days of World War I. Greene, a forward thinker, allowed the Salvation Army and other businesses to construct commercial buildings. Restaurants, a jeweler, a bank, and a photography studio sprouted up to serve the soldiers' needs, which was a new concept for military posts. The idea was to care for the soldiers' needs on the post rather than have them travel to the rough-and-tumble cities of Tacoma and Seattle. Hoping to provide alternative, wholesome recreation, Greene established an "entertainment zone" just outside the camp on land that is now part of Lakewood's Tillicum neighborhood and North Fort Lewis. The amusement park opened in February 1918.

Camp Lewis then became Fort Lewis. McChord Field formed a nearby Air Force base after World War II. The facilities formally joined in 2010 to become Joint Base Lewis-McChord, one of the largest bases

in the continental United States. The base commands some 40,000 soldiers and civilian workers as well as supporting 120,000 military retirees and more than 30,000 family members living both on and off the post. Joint Base Lewis-McChord is the largest employer in Pierce County. Payroll, contracts, and civilian workers with military ties now represent about $3 billion in annual spending, accounting for Joint Base Lewis-McChord and the National Guard operations centers at Camp Murray in Tillicum.

Few military, humanitarian, or emergency operations around the world occur without having some ties to local military bases, whether the missions are deployments to hot spots, supply runs to the Arctic, or federal disaster relief efforts. Since the bases are so large and located in choice spots in America, retirees often reside close by, providing communities like Lakewood with a deep pool of volunteers and organizers. It has been said that people can't spill their coffee in Lakewood without hitting the shoes of a retired Army or Air Force officer, and that saying is not far off the mark.

The Fort Lewis Museum is located in the former Salvation Army center, which provided comfort to soldiers as the Red Shield Inn. The area around the museum is known as Greene's Park, which was also the name of the World War I entertainment zone. Henry A. Greene No. 250 of the Free and Accepted Masons of Washington was formed in 1921 and continues to meet at its Lakewood lodge to this day.

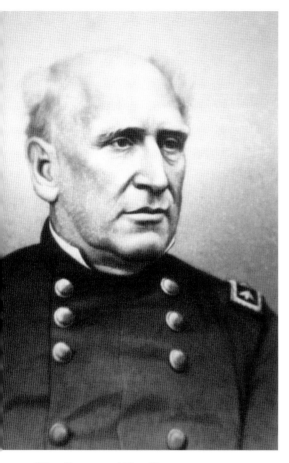

Silas Casey and Ken Morgan

US Army colonel Silas Casey (left), a graduate of West Point, had a long history of battling Native Americans when he arrived at Fort Steilacoom on January 17, 1856. He led soldiers into battle against natives within weeks of his arrival. He had a different kind of battle with white civilians. Casey strongly disagreed with Washington's territorial governor, Isaac Stevens, who wanted the Indians further punished. When Stevens had Nisqually leader Leschi put on trial for murder, Casey housed him at Fort Steilacoom to reduce the odds that the civilians would hurt him. Casey later served as a major general during the Civil War. His manual on drilling and conduct of troops is used today by military re-enactors. The right photograph shows re-enactor Ken Morgan, who has been portraying Casey at living history events for more than two decades. (Left, courtesy of Historic Fort Steilacoom Association; right, photograph by Ed Kane.)

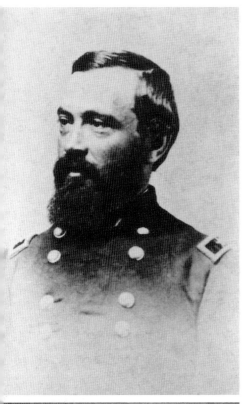

August Kautz

Lt. August Valentine Kautz was instrumental in designing and supervising the construction of buildings at Fort Steilacoom in 1857 and 1858, four of which remain today. Like Casey, he was a veteran of the Mexican War. Kautz unofficially married Kitty, the daughter of Quiemuth, a leader in the local Nisqually tribe. They had two children. Kautz participated in the first attempt by whites to ascend Mount Rainier. He returned from the 1857 trip suffering from snow blindness and frostbite. (Courtesy of Historic Fort Steilacoom Association.)

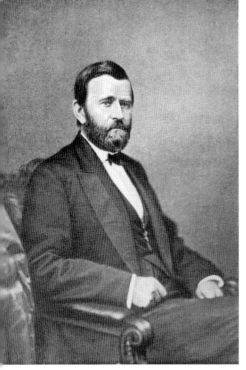

Ulysses Grant

Union general and 18th president of the United States, Ulysses S. Grant, would apparently have rather ended his military career early and settled in the Pacific Northwest had history not demanded he follow a different path. Lieutenant Grant was touring the region as a military quartermaster in the early 1850s when he was stationed at Fort Vancouver. He wrote to his wife about the great opportunities found in the area and a desire to make a fortune from farming rather than fighting. (Courtesy of Historic Fort Steilacoom Association.)

George Pickett

Capt. George Pickett, who graduated at the bottom of his class at West Point, had something to prove. Based at Fort Steilacoom, his Company D was dispatched in August 1856 to Bellingham Bay to construct and occupy a post, which they named Fort Bellingham. He became involved in an odd incident with Britain, later called the "Pig War." He is most famous for actions during the Civil War. (Courtesy of Historic Fort Steilacoom Association.)

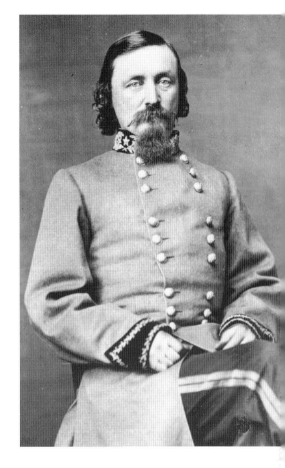

George McClellan

George Brinton McClellan received orders in 1853 to survey the most appropriate route for the transcontinental railroad between St. Paul, Minnesota, and Puget Sound, which was anchored by Fort Steilacoom. McClellan selected Yakima Pass without a full scouting of the area and was ordered by Governor Stevens to hand over his notes for an independent review. He refused and returned to the East Coast for another assignment. He is best known as a major general in the Civil War and Democratic nominee for president in 1864. (Courtesy of Historic Fort Steilacoom Association.)

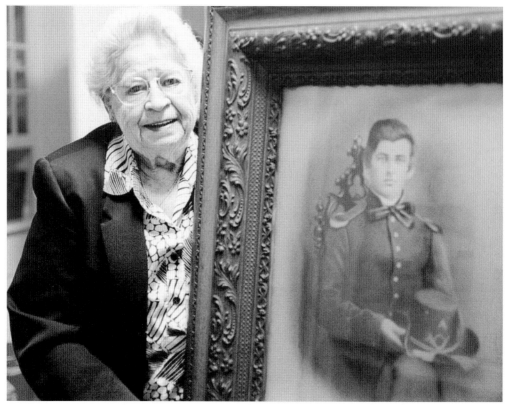

William Hipkins

William Stephen Hipkins served in the Union Army, including during Gen. William Tecumseh Sherman's famous "March to the Sea." Hipkins staked a land claim near Steilacoom Lake, known as Byrd Lake at the time, to start a farm. He gave his name to Hipkins Road, which marks the route to his land. Descendent Helen Peterson (shown here) donated his portrait to the Lakewood Historical Society museum. (Photograph by Steve Dunkelberger; courtesy of Historic Fort Steilacoom Association.)

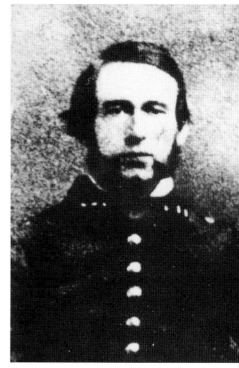

William Slaughter

Lt. William Slaughter helped found the Steilacoom Masonic Lodge and invested in 32 town lots. On December 3, 1855, Slaughter and his command camped at the forks of the Green and White Rivers, where he was killed by a Native American sniper. After the Civil War, when the Army disbanded Fort Steilacoom, Slaughter's remains were reinterred in 1892 in the military cemetery at the Presidio in San Francisco. (Courtesy of Historic Fort Steilacoom Association.)

TRUTH TELLER.

DEVOTED TO THE DISSEMINATION OF TRUTH, AND SUPPRESSION OF HUMBUG.

EDITED BY ANN ONYMOUS. : teilacoom, W.T., February 1, 1858. VOl. NO. 000.

TO THE PUBLIC.

Had a plain statement of Facts and no ll..r exercise of imagination, been mad by the parties who drew up the resolution adopted by the recent meetings at Stell coom and Olympia, relative to the case Leschi, there would have existed no neces ty for the undersigned to vindicate himse from the false charges made against his co duct as U. S. Commissioner. In times popular excitement, much injustice is apt be done to individuals, and although a coo er temper will undoubtedly ensue, and man regrets be made by those who are most sa age in their demonstrations; still, the u dersigned thinks that he has not the righ altogether, to remain quiet; but that he owe a duty to himself, his friends and to society te state plain and honest Truth.

On the morning of the 22d of January, a affidavit was made before me by an Indian te the effort, that Mr. Williams, who reside near Fort Steilacoom, had on a certain oc casion sold a quantity of whisky to an Indi as. As I am the U. S. Commissioner it was my duty immediately to issue a warrant for the arrest of said Williams, which I accord ingly did. It was served upon him by Mr. Kautz, a citizen of this Territory, whom I

Leschi

Following the so-called Indian War of 1854–1856, Leschi was put on trial for murder, even though any actions he took were during a time of war. The first jury offered a hung verdict, but Governor Stevens did not like that outcome, so Leschi was tried again. Fort Steilacoom's soldiers got to know Leschi while he was housed at the fort between court sessions. Several officers, including August Kautz, published a newspaper, the *Truth Teller*, printing evidence that Leschi could not have been where the prosecution said he was. It didn't matter. Stevens wanted Leschi dead. Silas Casey would not allow the gallows to be erected at Fort Steilacoom, but civilians took Leschi to a prairie by Lake Steilacoom. On February 19, 1858, Leschi was hanged. A Historical Court of Inquiry held a trial in 2004 and exonerated Leschi by a unanimous vote. (Courtesy of Historic Fort Steilacoom Association.)

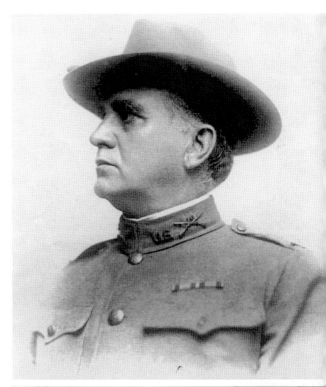

Henry A. Greene
Maj. Gen. Henry A. Greene, seen here representing both of his local commands, led Camp Lewis when it opened in September 1917. Greene did what many people thought impossible. He not only oversaw the massive construction of Camp Lewis and prepared soldiers for war, he also ensured that the needs of his soldiers were locally met so that they didn't have to venture to the tempting and tough city of Tacoma. He did this by recognizing the needs of his soldiers and the willingness of local businesses to tend to them. Realizing that soldiers wanted activities for their free time, he established business partnerships. Local businesses offered movies, dining, and entertainment outlets for the soldiers close to the military installation. (Courtesy of Fort Lewis Museum.)

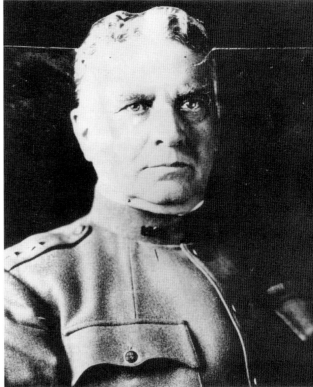

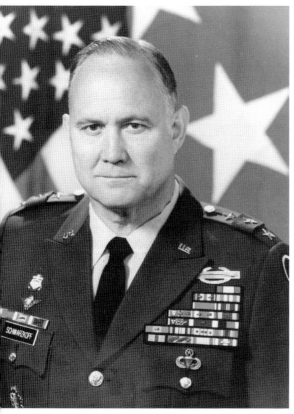

Norman Schwarzkopf

Lt. Gen. H. Norman Schwarzkopf preceded Lt. Gen. William Harrison as commander of Fort Lewis, serving from June 1986 to July 1987. He became famous around the world as "Stormin' Norman" while leading coalition forces in the Persian Gulf War of 1990. He commanded an international force of some 750,000 troops during Operation Desert Storm. Schwarzkopf retired after the war and took on a second career of philanthropy. He died in 2012. (Courtesy of Fort Lewis Military Museum.)

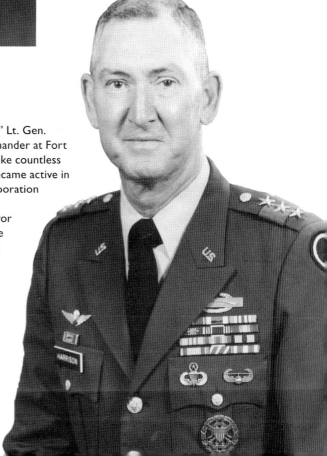

William Harrison

Long before he was the "Father of Lakewood," Lt. Gen. William "Bill" Harrison was the I Corps commander at Fort Lewis, from July 27, 1987, to August 3, 1989. Like countless Army and Air Force retirees, he stayed and became active in Lakewood community life, including the incorporation efforts of the early 1990s. The 1996 effort succeeded, and Harrison became the first mayor of Lakewood, solidifying the bond between the city and the nearby military bases (now united as Joint Base Lewis-McChord). (Courtesy of Fort Lewis Military Museum.)

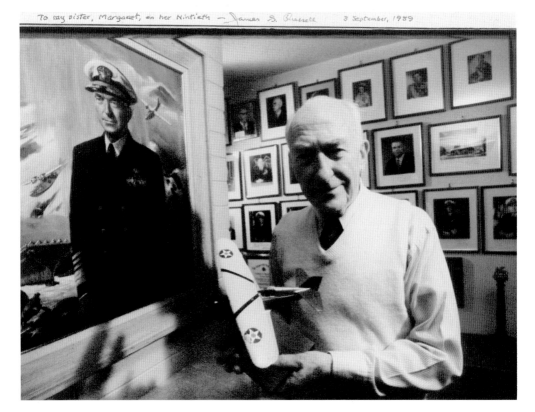

To my sister, Margaret, on her Ninetieth — James S. Russell 3 September, 1989

James Russell

James Sargent Russell is probably the most famous military man to be raised in Lakewood. Born on March 22, 1903, he attended DeKoven Hall School, a private school in Lakewood that became the DeKoven Inn and, later, the DeKoven Apartments. Russell, a noted sailor who was often spotted on and around American Lake, became a merchant marine before studying at the US Naval Academy and entering the Navy in 1926. His career, which spanned the use of biplanes and atom bombs, transitioned from conducting sea battles to coordinating multi-force assaults. Russell's service during World War II included combat missions in the Aleutian Islands. He received the Distinguished Flying Cross, the Air Medal, and the Legion of Merit. After the war, he commanded an escort carrier before reporting for duty at the US Atomic Energy Commission, where he commanded the commission's task group on Operation Sandstone, the atomic bomb tests of 1948. Then came service aboard the aircraft carrier *Coral Sea* and at the Office of the Chief of Naval Operations, where he served as head of the Military Requirements and New Development Branch, Air Warfare Division. He became the director of the division in 1953 and was promoted to the rank of rear admiral. He was honored for his work in developing the Vought F-8 Crusader supersonic fighter two years later. Russell later served as deputy commander of the Atlantic Fleet before being appointed vice chief of naval operations as a four-star admiral. He went on to be the commander of NATO's Allied Forces Southern Europe before retiring in 1965.

His father, Ambrose J. Russell, was a missionary in India before settling on a career as an architect, designing landmark buildings. He was born in the East Indies on October 15, 1857, and was educated at the École des Beaux-Arts in Paris and studied with 19th-century Boston architect Henry Hobson Richardson before coming to the Pacific Northwest. He designed the Washington governor's mansion, Tacoma's Temple Theater, The Tacoma Armory building, the Commerce Building, and the Perkins Building. (Courtesy of the Russell family.)

CHAPTER THREE

Early Community Builders
Strong Wills, Strong Accomplishments

Thousands of people have built Lakewood into a community. They include the men and women who came out to what was then the middle of nowhere to bring mental-health care to the patients at Western State Hospital. They include pioneer settlers like John Flett, whose Flett Dairy was among the businesses that served the small settlements that made up the Lakes District.

The pioneers who left the most written and photographic records are the tycoons. One of them, H.F. "Bert" Alexander, bequeathed to the community Lakewold Gardens. The Georgian-style mansion, sitting on 10 acres along Gravelly Lake, is a reminder of how the rich lived. Lakewold's rare and native plants, state champion trees, over 900 rhododendrons, 30 Japanese maples, and stunning statuary show the influence of famous landscape architect Thomas Church. He was one of the Modernists who popularized the concept of the outdoor living room, which requires dedication in rainy Washington. Church also produced commercial projects, such as master planning for the University of California at Berkeley and at Santa Cruz.

But, before there could be a Church, there had to be the Alexanders. It was Bert Alexander's mother, Emma, who spotted the lakefront lot in 1908. Just 15 years earlier, the family could never have imagined themselves living anywhere but a hovel; the father had been left destitute by the Panic of 1893 and was physically disabled.

Bert Alexander, 14, had dreamed of going to Harvard. Instead, he found himself begging for work on the docks of Tacoma. The boy had two advantages, though. First, he was built like a tank—when other men carried one bag, he carried two. The union men, in fact, asked him to carry less because he made them look bad.

His second advantage was determination. On his very first day, Alexander earned 20¢ an hour. He heard that there was a crew that earned 40¢. So, he went to the crew supervisor and asked for a job on his team. The man looked the boy over and said "no." Alexander then went to the supervisor's supervisor. That man also refused. Alexander then tracked down the supervisor's supervisor's supervisor. The man grinned, said he admired the boy's gumption, and said "yes." He warned Alexander that because he had gone over the heads of two other bosses, he would have to work harder than anyone. The boy said he would. In three years' time, the 17-year-old had done so well, he was supervising crews on the docks. When a crew refused to follow instructions, Alexander grabbed a cargo hook and, using his mighty arms and hands, straightened it into a spear. He then instructed the men to get moving. They did.

That story, by the way, was not one that Alexander told. Among the workers that day was the father of a Tacoma journalist who wrote an admiring story of what happened to the teenager. Then, three years

later, with funds from Tacoma financiers who recognized his drive, Alexander bought his first dock. He followed that by purchasing his first ship. Alexander moved operations to Seattle for a while, but he was known as "the kid from Tacoma."

Bert Alexander leveraged his knowledge of the docks and shipping, and of Tacoma investors, into the largest shipping line on any coast in the world. His ships worked the route from Alaska to California, dominating 60 percent of the freight market. Thus was created the fortune that began Lakewold Gardens.

Meanwhile, as the nation entered the Jazz Age, people with money wanted to go on cruises. How Bert Alexander's enterprise became his day's version of Carnival Cruises is a story in itself. After World War I, the Navy employed a fast ship to carry admirals around in luxury. Alexander went to Pres. Warren G. Harding and said the Navy was squandering $1 million a year in operations on that ship; if the Navy sold the ship to him, he could turn it into a business that would generate tax revenues. He bought the ship, but before reaching the West Coast, it caught fire and sank.

So, Alexander bought the second-fastest ship. He had won a contract to carry 1,000 Shriners from San Francisco to Hawaii. The ship steamed out of New York with such ferocity that it rammed a British freighter, which sank. The ship had to go back for $60,000 worth of repairs, and the owners of the freighter put a lien on Alexander's vessel for $1.5 million. The Shriners, meanwhile, already had their plans. So, Alexander began efforts to raise $1.5 million. The boat set sail—Alexander joked that people on it were disappointed it didn't stop in Cuba for parties—and went full speed. When it docked in Los Angeles, Alexander had laundry and supplies sent ashore so they could be cleaned and shipped to San Francisco. Within 20 hours of putting in to San Francisco, the ship, the *H.F. Alexander*, was off: 10,000 loved ones and friends waved goodbye to the Shriners.

At their peak, Alexander's companies employed 12,500 people and owned 90 percent of the luxury market from Nome to Los Angeles. That and the freight business generated $11 million a year in profits. But others found ways to buy stock in his companies and take over, and he lost his fortune. The arrival of trucking didn't help. By the late 1940s, Alexander had a vision of a different kind of shipping: putting cargo on vehicles and driving them onto ships. He was trying to get financing for two such containerized ships when he died, 30 years before other companies used such techniques to drive big business at the Port of Tacoma.

An intimidating man, Alexander could also be playful, as seen in the photograph on the cover of this book with his grandson, Joseph Carman III. The Alexander and Carman families were able to give Joe III, who would go on to study at Yale, a much different upbringing than H.F. had. Such was the luxury life around the Lakes District.

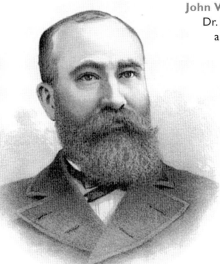

John Waughop

Dr. John Wesley Waughop witnessed the horrors of the Civil War as a surgeon's assistant in the battles of Shiloh and Vicksburg. He became superintendent of the Washington State Hospital for the Insane in 1880. Now called Western State Hospital, the facility has always been a major employer in Lakewood. Waughop and his wife believed that nature was good for patients, and they are responsible for planting the rare trees at the hospital and nearby Fort Steilacoom Park. The orchards remain a spot of interest to plant lovers and naturalists to this day. (Courtesy of Western State Hospital.)

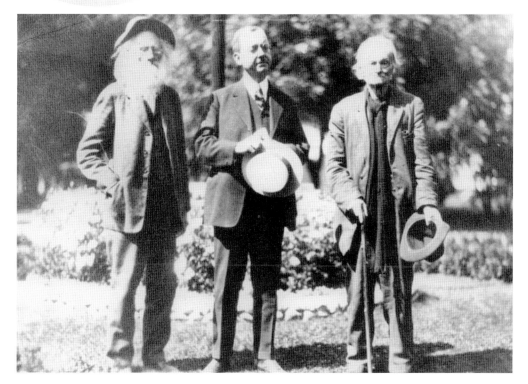

William Keller

Western State Hospital was created when the US Army left Fort Steilacoom. Here, its longtime superintendent, Dr. Keller (center), gives a tour to Ezra Meeker (left) and an unidentified pioneer. It would have been fascinating to hear Meeker describe the scenes as he remembered them as he walked the former fort. Keller himself was historic for twice serving as head of Western State (1914–1922 and 1933–1949), bringing new treatments to the hospital and expanding the large farm that has since become a park. (Courtesy of Western State Hospital.)

31

Bank of Tacoma Picnic
The lakes of Lakewood attracted visitors wishing to "get away." Here, National Bank of Tacoma employees hold their annual picnic at the DeKoven Inn on the east side of Lake Steilacoom in August 1925. Although the DeKoven Inn, which previously had been a boys' school, was destroyed by fire on August 2, 1925, the resort's dance and banquet hall was saved and became a new inn. (Courtesy of Tacoma Public Library.)

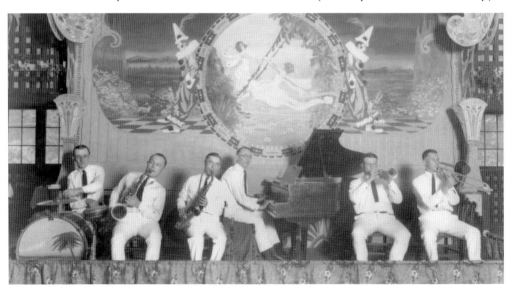

Ingleside Orchestra
Time has wiped away both fancy and informal party spots in Lakewood. Here, the orchestra performs in January 1924 at the Ingleside Sunken Gardens at 12914 Pacific Highway Southwest in the Ponders area. The upscale club, built in 1921, was modeled after the Green Mill Gardens of Chicago and contained 28 sets of French doors and 18 miles of latticework. The club was destroyed by fire in 1936. (Courtesy of Tacoma Public Library.)

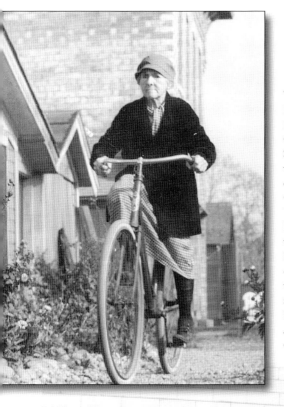

The Southwells and Lucy Farrar

Lakewood has a long history of cycling enthusiasts. In the below photograph, American Lake resident G.A. Southwell bikes with his grandson Harold Southwell, four, in 1925. Young Harold, believed to be the youngest cyclist in Pierce County, is on a special bicycle built for him by his father, A. George Southwell. A decade later, the *Tacoma Times* featured sprightly 81-year-old cyclist Lucy D. Farrar (left), who said she was a living testament to the health benefits of bicycle riding. Farrar had been an avid bicyclist for 40 years, since the cycling craze in the Gay Nineties. She bought the bike shown here at a 1917 Red Cross salvage sale. Farrar lived at 5647 South Alder Street in Tacoma and had a second home on South American Lake to which she cycled, a round trip of 14 miles. (Courtesy of Tacoma Public Library.)

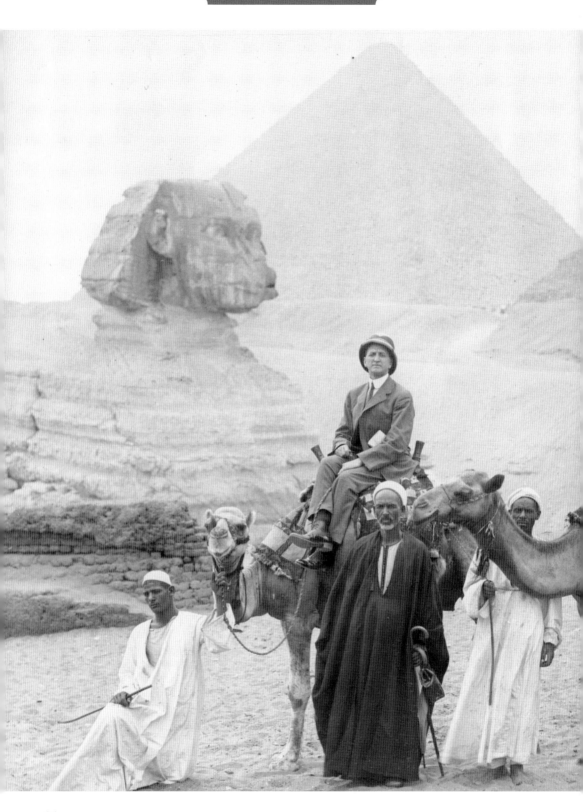

The Carman Family

At the turn of the 20th century, families with means took trips around the world, and Joseph and Margaret Carman were no exception. The family cruise took them to Japan and other exotic locales between February 5 and May 13, 1910. The couple is seen here in Egypt with their son, Joseph Carman Jr., who went on to marry the daughter of another wealthy family, the Alexanders. Both families left behind a wealth of photographs from a different time. (Courtesy of Joseph L. Carman IV from the Carman family collection.)

The Carmans
Joe Carman I is seen about 1920 in the photograph on the right. He had come to Tacoma in 1890 and established the mattress company Carman Manufacturing. In 1919, the family bought land on Gravelly Lake and began construction of the Italianate-influenced Villa Carman (later known as Villa Madera). In the family photograph below, taken at Villa Carman, are, from left to right, Joseph III; his mother, Dorothy (Alexander) Carman; Joseph and Margaret Carman; and Joseph Jr. The house and gardens were a popular social center until the couple died in 1938. The grounds were subdivided for housing in 1971. The grand home was later owned by actress Linda Evans (see page 121). (Courtesy of Joseph L. Carman IV from the Carman family collection.)

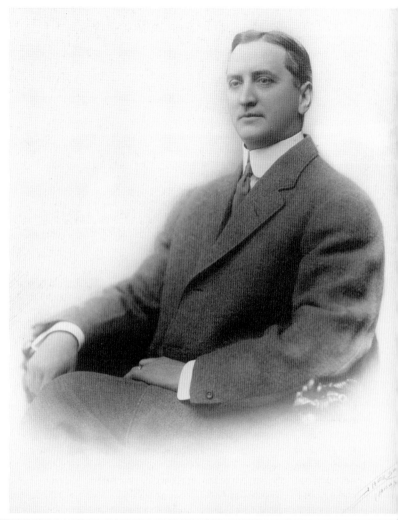

Emma Alexander

The Carmans' son married into the Alexander family. In this undated photograph, Dorothy Alexander's grandmother, Emma, sits outside what would later become an international destination, Lakewold Gardens. Emma had spotted the property in 1908, when streetcars were providing better access to the Lakes District. When Interlaaken was platted, Emma bought lot 23 and built a small summer cabin on the property. The gardens were already locally famous in 1913, when the *Tacoma Daily Register* ran the headline "Nature-loving Tacomans make modern Arcady of Gravelly Lake's Shores." Emma transferred her lakeside property to her son, Hubbard Foster Alexander, and his wife, Ruth, in 1918. The Alexanders had a house in Tacoma at Fifth Street and Yakima Avenue, and used the house at Gravelly Lake as a country retreat. The Alexanders bought an adjoining five-acre lot, creating the 10 acres that today makes up Lakewold. They hired designers to lay out the home and gardens to capture views of Gravelly Lake and Mount Rainier. The family entertained at the lakeside estate with lawn parties and family weddings. Ruth named the estate "Inglewood." Maj. Everett Griggs and his wife, Grace, purchased the property in 1925 and renamed it "Lakewold," a Middle English term meaning lake-woods. In 1938, the Griggs sold Lakewold to George Corydon and Eulalie Wagner. George was the son of a prominent Tacoma physician, vice president and treasurer of the St. Paul & Tacoma Lumber Company, and president of the C.W. Griggs Investment Company and of the Wilkeson Company. She was the daughter of a prominent Seattle lumber family, the Merrills, and is remembered for her dedication and her contributions to the practice of landscape gardening, epitomized by Lakewold Gardens. Eulalie was a member of the board of directors of the Garden Club of America from 1962 to 1966. Today, Lakewold Gardens is popular as both a house museum and an estate garden. (Courtesy of Joseph L. Carman IV from the Carman family collection.)

H.F. Alexander and Ruth Alexander (BELOW AND OPPOSITE PAGE)
In the top photograph on the opposite page, H.F. "Bert" Alexander and Ruth Alexander relax on their yacht. Ruth was an avid gardener, and a rose is named for her. The family is in possession of a silent film taken on the yacht. In it, Ruth fusses over H.F.'s collar and then looks at the camera, looks back at H.F., and then sticks her tongue out at him. H.F. erupts into laughter.

In the photograph below, Alexander hoists his grandson, Joseph Carman III, on his shoulders. The families doted on the boy, who went on to attend Yale. In what was a likely inevitability, the Alexander girl and the Carman boy later married. In the bottom photograph on the opposite page, an enlargement of one of several in which the subjects rehearse their poses, Dorothy and Joseph Carman look unusually relaxed. She is trying to get a reluctant dog to stand still on the Lakewold fountain, and Joseph is enjoying the scene. There is no final, formal version of this photograph in the archives, so it might be that the dog won out. (Courtesy of Joseph L. Carman IV from the Carman family collection.)

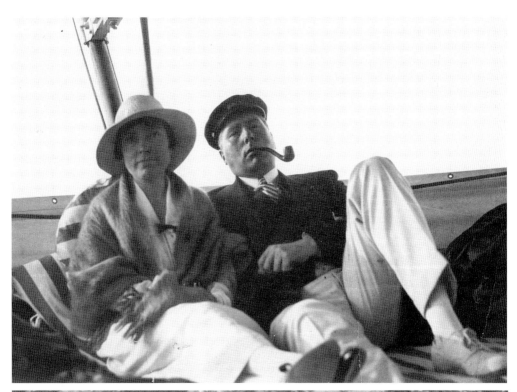

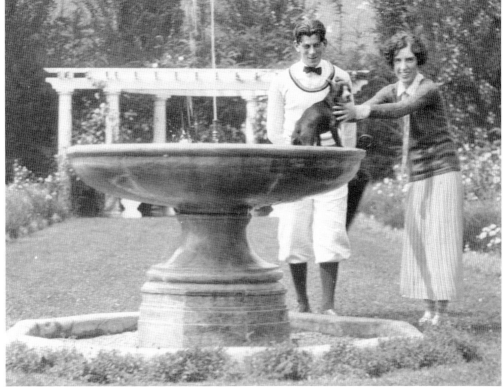

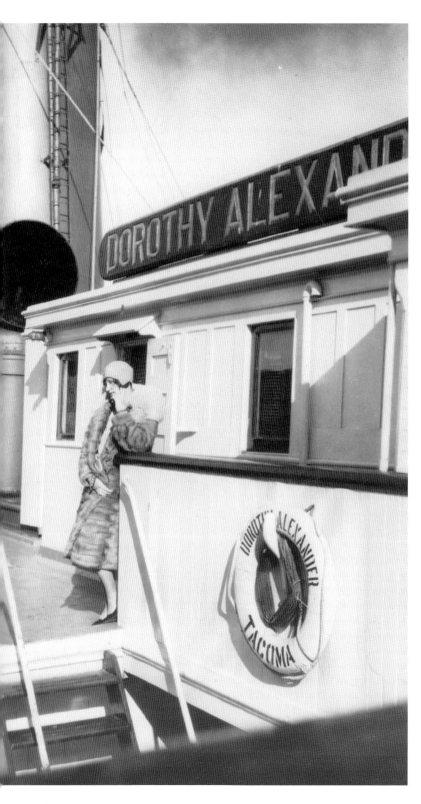

Dorothy Alexander
Dorothy Alexander poses on the ship that carried her name. H.F. Alexander named his ships after the women in his life: the *Emma Alexander*, the *Ruth Alexander*, and the *Dorothy Alexander*. People who cruised on these ships have left behind written memories of their experiences. The ships are also mentioned in oral histories of the African American community. The sad truth is that passengers were white and the crews were black, clad in bright white uniforms. Many men recalled their time on these ships as their first entry into the working world. (Courtesy of Walter Neary collection.)

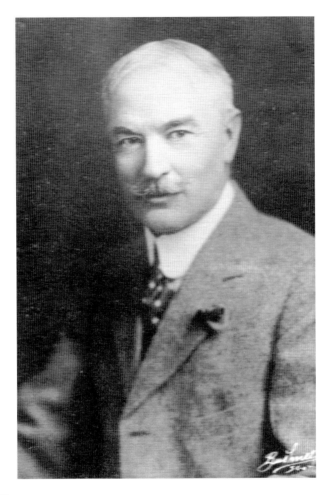

Chester Thorne

Thorne built what is now a popular bed-and-breakfast, Thornewood Castle, operated by the Robinson family, the site of the Stephen King movie *Rose Red*. Thorne was a New York Quaker who became a wealthy railroad baron. He graduated from Yale in 1884, worked for a railroad company, and then shuttled from Tacoma to Europe on financial trips over the next few years. The Panic of 1893 wiped out most of the businessmen of the time, but Thorne steered the National Bank of Commerce in Tacoma to success by raising $200,000 and covering its deposits. It was not possible to borrow money then; Thorne had to find cash, and some of it came from the family fortune that would have been wiped out had the bank failed. Thorne built his dream house on what was then prairie land next to American Lake. Construction started in 1908 and lasted three years. The year after he started building the house, which he named Thornewood, he owned three-fourths of the National Bank's stock. The Tudor-style mansion included many features that had been dismantled from a 15th-century English castle and brought to the site on three ships Thorne commissioned specifically for the trip around Cape Horn. He served on boards and helped to steer enterprises as varied as the Tacoma Port Commission, Tacoma General Hospital, and the precursor to the county health department. Thorne had faith in the potential of Mount Rainier to attract tourists, and he supported organizations on the mountain. At one point, he extended $90,000 out of his pocket so operations on the mountain could continue. His death made the front pages of newspapers in 1927. Ships in the Pacific Steamer Ship Company fleet were ordered to fly their flags at half-staff. The list of pallbearers at his funeral read like a who's who of Tacoma's history, including J.F. Weyerhaeuser and William Rust. (Courtesy of Joseph L. Carman IV from the Carman family collection.)

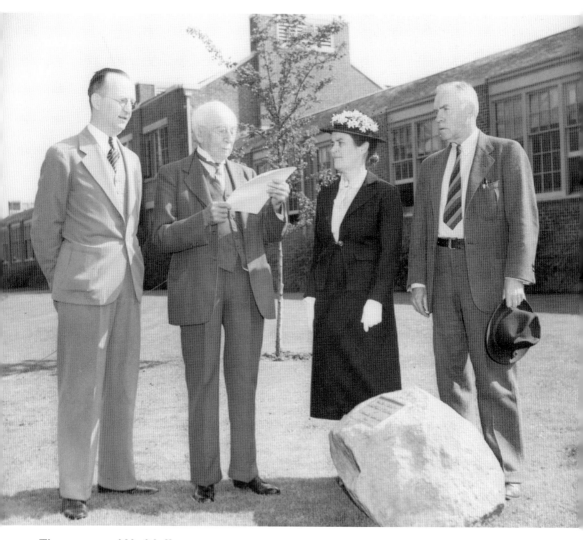

Thompson and Hudtloff

The massive beard that belonged to Lakewood visionary Walter Thompson (see page 17) was gone in 1939. He is seen here, second from left, holding the speech he would deliver when Clover Park High School dedicated its athletic field to him. At left is Clover Park superintendent A.G. Hudtloff, who helped unite the sprawling and independent neighborhoods of the Lakes District under the umbrella of the school district. On the right are Mrs. A.S. Black and Ray Thompson, Walter's son. The district named the field after Thompson, who donated the initial $1,000 to get the project started. It was completed as a WPA project. In a separate ceremony, the Garden Club dedicated a plaque and stone in memory of Thompson's deceased wife, Amarilla. The schools have played a major role in the Lakewood community. Iva Alice Mann, referred to by many as the mother of the Clover Park School District, helped combine the Park Lodge, Custer, Lake City, Lakeview, and American Lake South schools into one district. The combination allowed for a junior high school, Union School District No. 204, in 1928. She watched the district grow and helped another consolidation under the name Clover Park School District in 1941. (Courtesy of Tacoma Public Library.)

Ray Thompson

Ray Thompson is dressed for a costume party at the Lakewood Ice Arena in 1949. Mrs. M. Morton is dressed as the mouse. Thompson was president of the Tacoma Board of Realtors and, in 1948, was the first president of the Tacoma World Affairs Council. He and his wife, Lillian, visited China, meeting Chiang Kai-shek and his wife, Soong May-ling, who later visited the Thompsons at their Gravelly Lake home. Lillian, an English immigrant who had been a writer for the *New York Herald*, was one of the founders of the Lakewood Players. (Courtesy of Tacoma Public Library.)

Perry and Marian Crothers

Lakewood residents had plenty of fun in the old days, as well. In January 1949, the Lakewood Dance Club hosted a surrealist ball, which it called a "Daliesqe Evening," at Lakewood Center. The celebration of modern art was chaired by Perry and Marian Crothers, seen here. (Courtesy of Tacoma Public Library.)

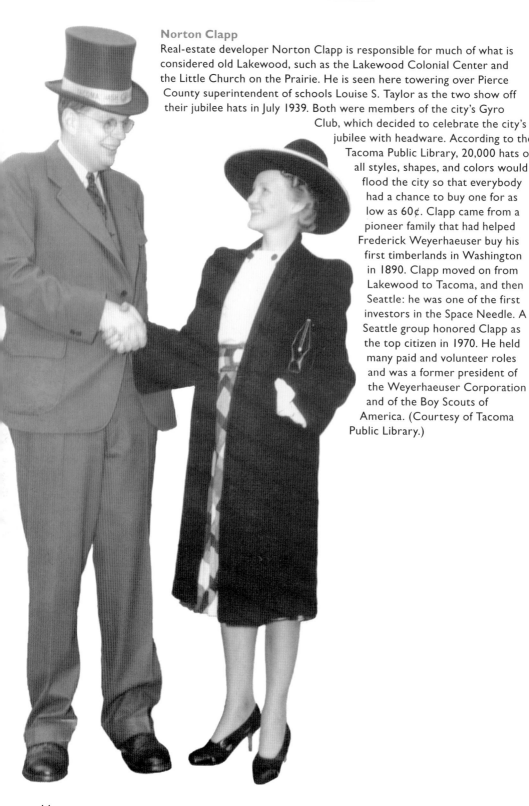

Norton Clapp

Real-estate developer Norton Clapp is responsible for much of what is considered old Lakewood, such as the Lakewood Colonial Center and the Little Church on the Prairie. He is seen here towering over Pierce County superintendent of schools Louise S. Taylor as the two show off their jubilee hats in July 1939. Both were members of the city's Gyro Club, which decided to celebrate the city's jubilee with headware. According to the Tacoma Public Library, 20,000 hats of all styles, shapes, and colors would flood the city so that everybody had a chance to buy one for as low as 60¢. Clapp came from a pioneer family that had helped Frederick Weyerhaeuser buy his first timberlands in Washington in 1890. Clapp moved on from Lakewood to Tacoma, and then Seattle: he was one of the first investors in the Space Needle. A Seattle group honored Clapp as the top citizen in 1970. He held many paid and volunteer roles and was a former president of the Weyerhaeuser Corporation and of the Boy Scouts of America. (Courtesy of Tacoma Public Library.)

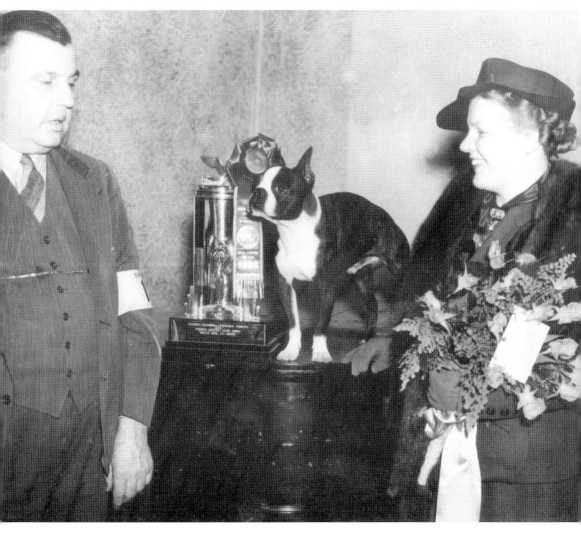

Mary Clapp
If Norton Clapp was the builder of Lakewood as it is known today, his wife, Mary, and her love of New England architecture were his inspiration. That's why the Lakewood Colonial Center, built in 1937, one of the first suburban shopping centers in the nation, has the look that it does. Here, in 1938, Mary is awarding the Tacoma Chamber of Commerce "Best Dog" prize to Jack Playfair, the Portland owner of Boston terrier Playfair Rockefeller, winner of the first annual Tacoma Kennel Club show. (Courtesy of Tacoma Public Library.)

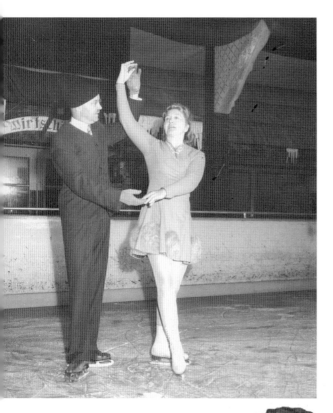

The Muellers
The teachers at the Lakewood Ice Arena, at 7310 Steilacoom Boulevard Southwest, from 1942 to 1947 were George and Leah Mueller. The German-born couple was hired in 1942 to replace John Johnsen, who spent World War II in Europe as a US counterintelligence officer, according to the Tacoma Public Library. The Muellers, internationally known skating instructors, had taught in Boston, Toronto, St. Louis, and Philadelphia. Arriving in Lakewood during World War II, they went by the less German-sounding name Miller. The arena was created by the same couple responsible for the Lakewood Colonial Center, Norton and Mary Clapp. (Courtesy of Tacoma Public Library.)

Patsy Hamm and Jack Boyce
Hamm and Boyce were the Pacific Coast junior pairs champions in figure skating's jumping pairs in 1948. They were representative of many amazing performers and athletes who came out of the Lakewood Ice Arena. Both Hamm and Boyce learned to skate at the Lakewood Figure Skating Club. (Courtesy of Tacoma Public Library.)

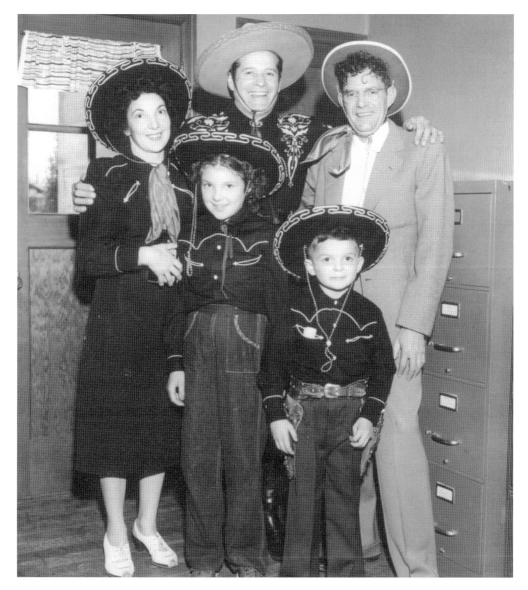

The Irwins

Lakewood was home to a couple of remarkable shopping areas: the Lakewood Colonial Center, one of the first suburban shopping centers in the nation; and the lively B&I, at 8012 South Tacoma Way, one of the coolest. The B&I often brought actors, athletes, and other performers to what is now Lakewood, including Duncan Renaldo, television's "The Cisco Kid," in October 1953. Here, Renaldo (rear, center) poses with B&I Circus Store owner Earl "E.L." Irwin, his wife, Constance, and their children Mary Lou and Ron. Opened in 1946 by Leo Bradshaw and Earl Irwin (hence the "B&I"), the store originally offered war surplus goods and hardware, according to the Tacoma Public Library. Irwin eventually bought out Bradshaw and increased the size and offerings of the complex, publicizing it with outrageous stunts such as a circus, wild animals, and a quarter of a million pounds of ice in a guessing contest. The crowds poured in. Earl Irwin died in 1973 at the age of 64, and Constance and his children continued to run the business. The B&I also played a key role in the saga of Ivan the Gorilla (see page 122). (Courtesy of Tacoma Public Library.)

Harry Lang
Few people in Lakewood's history served its children longer and in more ways than Harry Lang, who died at the age of 83 in 2001. Lang, a longtime Lakewood resident, served, coached, mentored, taught, and influenced thousands of students for more than 60 years. It was fitting that Lakewood Stadium was renamed Harry E. Lang Stadium in his memory.

His ties to the Clover Park School District started after a stint in the Army during World War II, when he served as an aerial gunnery instructor for the US Army Air Corps. He had never fired a gun until he started teaching the subject. After the war, Lang graduated from Pacific Lutheran College (now a university) and began his long association with students, parents, and staff with the Clover Park School District. He first worked as a teacher and coach at Clover Park Junior-Senior High School, routinely putting in 12-hour days before driving the activity bus to drop off students after sports practices. He coached basketball, football, tennis, and baseball, his first love. In three of the four years he coached the Clover Park High School boys baseball team, it posted undefeated seasons. Lang moved on to become a high school vice principal and junior high principal. He also worked as a demographer and statistician for the district.

In the fall of 1993, Lang was elected to a four-year term on the Clover Park School District Board, where he eventually took the reins as board president. He was also vice president of Lakewood Recreational Association and Washington Educational Association, a member of Phi Delta Kappa, past president of the Lakewood Kiwanis Club, chairman of the Department of Social and Health Services Pierce/Kitsap Child Abuse Advisory Committee, school liaison officer to the juvenile court, Clover Park Education Association Administrator of the Year, PTA Golden Acorn award winner, a life member of the Washington Congress of Parents and Teachers, a Washington Secondary School Athletic Administration Honor awardee, and a life member of the Disabled American Veterans and the Washington State School Directors Association.

He was active in school activities until his death, often taking his seat in the announcers' box at the stadium that now bears his name. He is interred next to his loving wife, Irene, at Mountain View Cemetery. (Courtesy of Clover Park School District.)

CHAPTER FOUR

Fighting Fire with Community

A Uniting Department

The Lakewood Fire Department was established in 1940. Legally known as Pierce County Fire Protection District No. 2, it was formed to provide fire protection for what was known as the Lakes District, a growing Tacoma suburb at the time. As more and more businesses and people located there, the need arose for greater fire protection. The idea had been simmering for years, but became apparent when Fort Lewis announced in 1939 that it would no longer be able to provide fire protection to the area.

At a September 1940 meeting of the Lakewood Community Club, it was decided to circulate a petition to the voters about forming a fire protection district. As certified by the Pierce County Commissioners, there were 245 votes for the formation of a fire district and only 41 against. The victory was the product of volunteers and boosters of fire safety in the increasingly populated suburb. Citizens formed the bulk of the firefighter ranks for many years. Starting in 1942, when the initial call for volunteers went out, and continuing for more than three decades, Lakewood citizens answered the call to protect their community.

The district's first three fire commissioners were elected on the same ballot as the formation of the district. Col. Ronald D. Johnson received 221 votes, Julius Mann received 215 votes, and Allen H. Link received 213 votes. They had also served on the volunteer committee tasked with studying the issue and bringing the matter to a public vote.

Firefighters from surrounding cities helped organize and train the volunteers, who had a single engine. The first station took shape at the former Evans-Burke garage, owned by Walt Evans, who played a crucial part in helping the new fire district and also became one of the first volunteers. The first alerting system for the Lakewood Fire Department was a single telephone connected to a siren atop the station, and a bell system. A bell was located outside the station, and two bells were inside the station. Additionally, there was a telephone extension located in Paul Hebb's Clover Patch, a business next door. Someone was usually there and could answer the alarm when the fire station was unoccupied. The first phone number, LA-3883, lasted many years.

On November 1, 1944, Bruce White was appointed fire chief and served in that position for more than 27 years. He was the perfect man for the job, not only because of his organizational mind and leadership skills, but because he loved the community. White was a charter member of the Lakewood Kiwanis Club, earning its Citizenship Award in 1965. In addition, he was listed in the 1967 roster of Outstanding Civic Leaders of America. He was the chairman of the Tacoma Soap Box Derby Association and safety chairman of the Tacoma-area Boy Scouts of America.

The first large-scale blaze faced by Lakewood firemen occurred in 1947, when four wards of Western State Hospital erupted in flames. Many patients escaped, one climbing down a ladder after the bars on his window were torn from the building with a chain. The fire claimed one life, that of a man on one of the upper floors. The district grew as surrounding areas wanted better fire protection. The district was approached by a citizen group from Tillicum in 1951, for example, with a proposal to jointly build a volunteer fire station in their community. The proposal included a suggested cost of $2,500 for the building, with all labor being provided by Tillicum citizens.

The fire district also helped grow the area, when the Visitation Villa, the former site of a Catholic girls' boarding school, was sold to commercial developers. The former school's barn needed to be removed, so firefighters used it for training, burning it to the ground to make way for what became the Villa Plaza shopping center. It is now the Lakewood Towne Center.

Other notable fires would follow, including ones at Tacoma Golf and Country Club and Meadow Park Golf Course. The 1970s saw a rash of arson fires, notably at Players Tavern, Exit Tavern, and Tiki Nightclub, which was Pierce County's first topless bar. The fires were later linked to a kickback conspiracy that involved mobsters and dirty cops, including the Pierce County sheriff. On December 8, 1978, a federal grand jury indicted 15 men in Pierce County, including Sheriff George V. Janovich, for engaging in a widespread racketeering conspiracy. The gang, known as "The Enterprise," was led by Tacoma mobster John Joseph Carbone. Most of the criminals spent time in prison. In February 1981, an arson fire took place at Clover Park High School Stadium and then at the gym the very next day. A student was later blamed.

On January 25, 2010, Lakewood's board of fire commissioners unanimously adopted a petition for merger, requesting to merge the Lakewood Fire Department into the University Place Fire Department. The matter went to a public vote. With an 82 percent affirmative vote, the two fire districts merged. With that vote, West Pierce Fire & Rescue was born, and the Lakewood Fire Department was dissolved. A museum dedicated to the history of the Lakewood Fire District can be found in the administrative office along Pacific Highway.

Chester Wallace
Chief Chester "Chet" Wallace led the department for 17 months, working tirelessly to improve the training for the volunteer forces and coordinating with the board of fire commissioners. In 1943, he made initial inquiries into civil service for the district. He was chief from July 1, 1943, until October 30, 1944, and worked with Walt Evans to form the district's first station, which is now the B&B Glass Company, located on Gravelly Lake Drive, just across from Clover Park High School. The two actually crafted the district's first engine, modifying a donated civil defense truck by adding a pump and water tank. The hose bed was constructed later, using donated plywood. (Courtesy of West Pierce Fire & Rescue.)

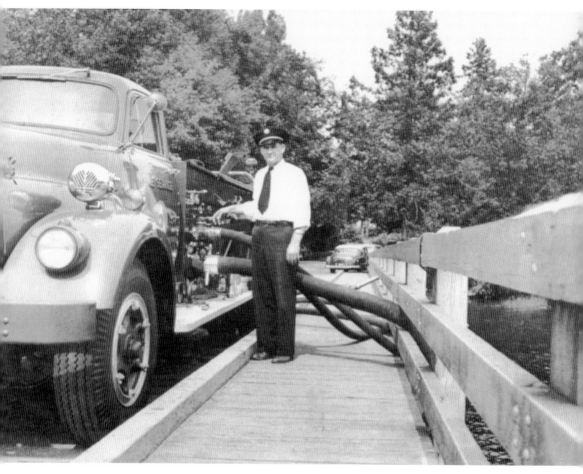

Bruce White
Chief Bruce White mans the pump panel to conduct the acceptance test of the new, 750-gallons-per-minute fire engine in 1954. The bridge is the Interlaaken span over Steilacoom Lake. White had an unparalleled career with the Lakewood Fire Department. He was the fire chief for over 27 years, between 1944 and 1972. White established many longstanding programs and was involved in every aspect of the fire district. He was also a well-respected member of several service groups of Lakewood, having been honored by many of them for his civic contributions and hard work. (Courtesy of West Pierce Fire & Rescue.)

Claude Legacy and John Brooks

Claude Legacy (center) and John Brooks (right) initiate a new firefighter into the ranks around 1963. The actual rite of initiation was a bit of a secret, a way to keep the brotherhood of firefighters strong on and off duty. The ceremony was known to be more about fun than a "trial by fire." There would be enough of that once the initiate reported for duty. (Courtesy of West Pierce Fire & Rescue.)

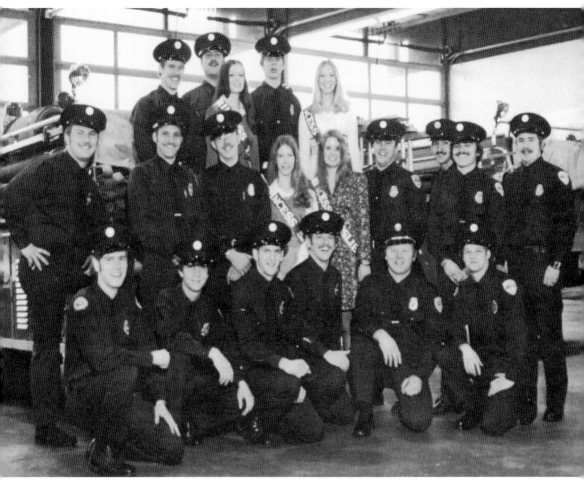

The Fab 15
Known as "The Fab 15," the group of new firefighters hired in 1975 pose here with four of that year's Daffodil Princesses. From left to right are (first row) Rick Ernst, Mike Keohi, Michael McGovern, Brent Work, Capt. Roy Merritt, and recruit instructor Dan Bloomingdale; (second row) Mike Qunell, Doug Christianson, Bob Bronoske, two unidentified princesses, Jim Benson, John Galvan, Bob Gunter, and Jim Rotondo; (third row) Mark Frohmader, Joe Rodgers, unidentified, Jeff Bontemps, and unidentified. Of the original Fab 15, Rodgers, Keohi, and Rotondo were still working on March 1, 2011, when the department merged and became West Pierce Fire & Rescue. (Courtesy of West Pierce Fire & Rescue.)

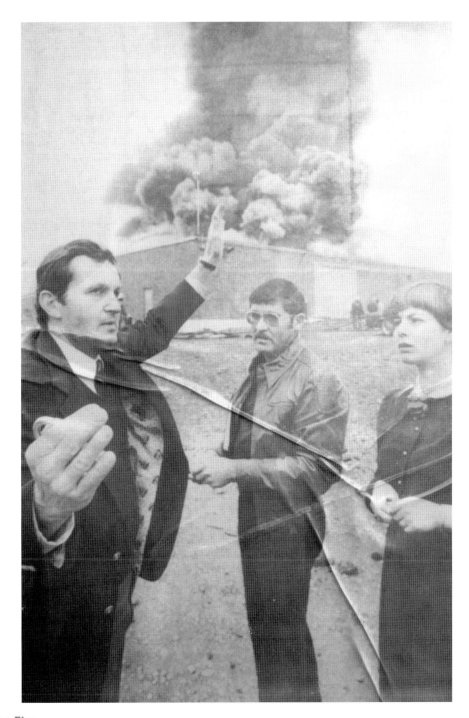

The Fire
Clover Park High School principal Jim Ellingson is pictured at the Clover Park High School fire in 1981. The fire occurred over two days in February and caused extensive damage to the school. The arsonist later turned out to be a student. The blaze prompted the renovation of the school. Only a few features of the original building remain to this day. (Courtesy West Pierce Fire & Rescue.)

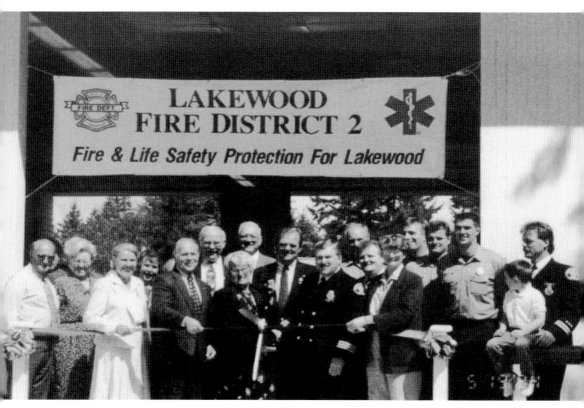

A New Station
Shown here is the grand opening of the new Station No. 2 at 8517 Washington Boulevard on May 19, 1994. The event included speeches by politicians, including county councilmember Sally Walker, state representative Gigi Talcott, and county executive Doug Sutherland. Also on hand was Chief Steve Marstrom, who served from February 1, 1990, to May 31, 1999. His tenure saw the district placed under cityhood in 1996 as well as the first attempt to consolidate with the University Place Fire Department. Marstrom was another chief who had advanced through the ranks. (Courtesy of West Pierce Fire & Rescue.)

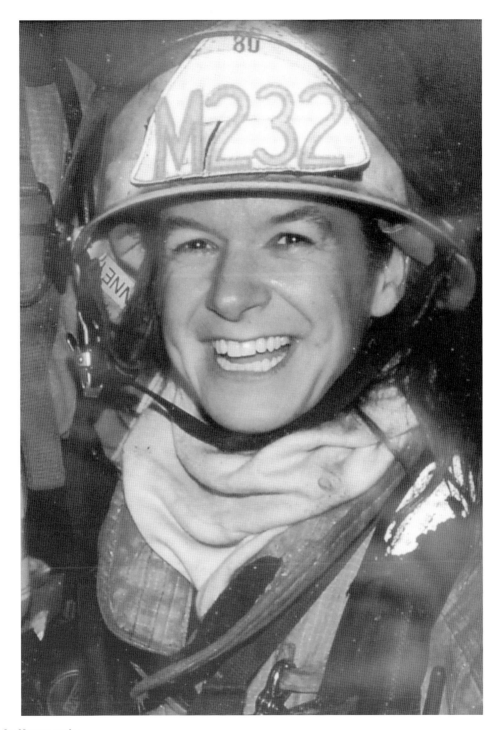

Jo Kummerle
The Lakewood Fire Department was an all-male club for much of its history. That changed in 2004, when the first female firefighter began serving. Firefighter Jo Kummerle is honored for that distinction at the Lakewood Fire District museum. (Courtesy of West Pierce Fire & Rescue.)

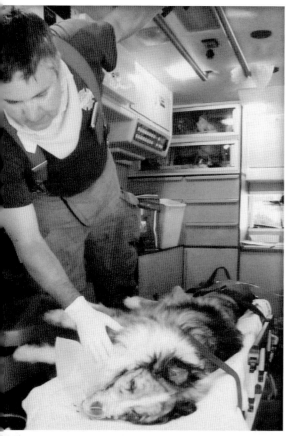

Roy Bean
Capt. Roy Bean saves a dog from a fire. It was just another day at the office for the veteran firefighter, who made the transition from Lakewood Fire to West Pierce Fire & Rescue. Bean has more than 20 years of service to Lakewood. (Courtesy of West Pierce Fire & Rescue.)

Mike Keohi, Jeff Bontemps, Ken Sharp, and Paul Webb
Seen here in 2006 are, from left to right, Keohi, Bontemps, Sharp, and Webb. All had long careers with the fire service and were instrumental in the administration of the Lakewood Fire District. (Courtesy of West Pierce Fire & Rescue.)

Paul Webb and Ken Sharp

Paul Webb brought a sense of humor to the position of fire chief. He gained the position by working through the ranks. Webb (left) is also credited with coining the district's motto, "Respond Efficiently, Execute Flawlessly, BE NICE!" Ken Sharp (right) served as the last fire chief of the Lakewood Fire Department. Having advanced through the ranks, Sharp also brought a high level of education to the job. He earned an executive masters degree in public administration from the University of Washington. Prior to becoming a chief officer, he served many years in leadership positions with the firefighters' local union, providing him with a unique labor/management perspective. While Chief Sharp held the distinction of being the last fire chief of the Lakewood Fire Department, he was also the first chief of the newly formed West Pierce Fire & Rescue. The men stand with Koree Wick, finance director. (Courtesy of West Pierce Fire & Rescue.)

Lakewood Fire District Museum
The fire station on Pacific Highway has a room dedicated to the history of the Lakewood Fire Department. It includes news clippings, equipment, and photographs of firefighters, as well as a written history of the district authored by Ed Hardesty, a retired captain from the Lakewood Fire Department. (Courtesy of Steve Dunkelberger.)

CHAPTER FIVE

Modern Notables
The Variety that Is Lakwood

It no doubt often happens that, on hearing the name "Lakewood," people say that they have heard of it and proceed to give an unflattering description of the town. They may refer to a crime they happened to hear about or, worse, the television show *COPS*, which seems to have filmed every other episode for years in the worst parts of Lakewood. Endless reruns of the show have made Lakewood look like a horrible cross between *Hee Haw*, a horror film, and a trashy talk show. No one knows how many fine soldiers who get assigned to Joint Base Lewis-McChord have moved to DuPont or Lacey or somewhere else because of *COPS*. The leaders of those other communities wisely told the show to mount its camera elsewhere.

There are, of course, positive aspects of Lakewood, not least being the Weyerhaeusers. The Federal Way–based forest products company still has a family attached to its name, and it is still based in Lakewood. In the early years of its fame, the family had been living in Tacoma, but in a sensational 1935 crime, 10-year-old George Weyerhaeuser was kidnapped. The boy was found safe, and the kidnappers were imprisoned, but the family could not be blamed for seeking more isolated lakefront property in Lakewood as a prudent summer retreat. Someone reading the authorized biography *Phil Weyerhaeuser: Lumberman*, by Charles E. Twining, quickly picks up on what George's parents, Phil and Helen, thought of their lakeside vacation home. It was a place where they could enjoy each other's company, away from distractions. In 1941, they were going to "have some fun together building a fence and pulling up Scotch broom," Phil wrote. Anyone familiar with Scotch broom weed, whose roots hold the soil like they were planted in concrete, can empathize with Phil Weyerhaeuser's pain.

His wife was skeptical, apparently. He wrote his uncle, "This was a compromise . . . and is an experiment, as far as Helen is concerned, as she insists I will sneak off to the office too much." Apparently, Twining writes, things worked out. Weyerhaeuser wrote to a friend, "Helen and I retired to our place on American Lake for two weeks, and got a wonderful rest out of it." The Weyerhaeusers began to spend more time there, and Phil joined the board of Lakewood's Little Church on the Prairie. The woodsman personally designed the benches for the sanctuary. In doing so, a man of his stature has something in common with countless other Lakewood residents who stepped up when something needed doing. There was little or no government to lean on, and no old pioneer city to leverage from.

That spirit of community building runs throughout Lakewood. Such is the case with its civic groups. The first of them was the Lakewood Rotary. In 1954, Ernie Thompson and Floyd Snider of the Tacoma No. 8 Rotary club contacted two men from Lakewood, Charlie Peterson and Bob Bernnard, and requested that they start putting some names together for a new Rotary club. Clearly not ones to move quickly,

especially Charlie, the Rotarians joke in their published history, it took two years to put together a list of 23 names. On March 16, 1956, in the Lakewood Terrace dining room, the first meeting of the new club was held, attended by 20 men. Among the participants were several from Tacoma No. 8. The meeting was chaired by founding father from No. 8, Floyd Snider.

No doubt there was some business conducted, though there was considerable discussion about the bumps on Chuck McCallum's head. Maybe one had to be there. McCallum, the second president of Lakewood Rotary, was clearly a good fit into the menagerie. Lakewood service clubs were off and running.

Edgar and Dwight Eisenhower

In February 1946, Gen. Dwight Eisenhower inspected McChord Air Force Base on a visit to Puget Sound. He then went to the American Lake home of his brother, Edgar Eisenhower. Posing here with President Eisenhower (left) and Edgar are Edgar's wife, Lucille (second from left), and daughter Janice. Edgar Eisenhower attended law school in Seattle and passed the bar in 1914. He founded the prominent Tacoma law firm that still bears his name, Eisenhower and Carlson. His younger brother, nicknamed "Little Ike" because Edgar was the older brother, started his meteoric rise up the military ladder at Fort Lewis and eventually served two terms in the White House.

Dwight Eisenhower first came to Fort Lewis in 1938 while on his way to a post in the Philippines. He loved stopping in the Evergreen State and sought a command post at Fort Lewis. His wishes came true the following year, when he took his first assignment, leading the 1st Battalion, 15th Regiment. Dwight's career boomed, and he rose from the rank of colonel in 1940 to General of the Army by 1944. He was Supreme Allied Commander in Europe during the planning and execution of the Normandy invasion in 1944. From 1953 to 1961, he occupied the White House as the 34th president of the United States. As fate would have it, his brother was one of his biggest critics. The ultraconservative constantly questioned his brother's policies. When the press asked Dwight about the criticism, he smiled and responded that Edgar had been "criticizing me since I was five years old."

Before Dwight became president, the two brothers liked playing golf. Edgar had a house along American Lake, and they played at a nearby country club. Edgar was better with the irons, and his victories included the Tacoma Country Club championship in 1955, a 1958 Pacific Northwest Seniors championship, and a Washington State Seniors championship. Edgar regularly golfed at the Tacoma Country Club, where he shot below par. He won the club seniors championship in 1965. At age 69, he shot below his age, with a 67. (Courtesy of Walter Neary.)

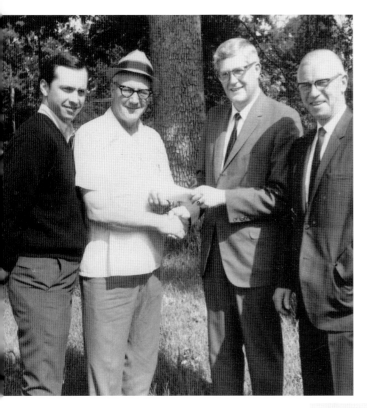

Fort Steilacoom Park
Seen here at Fort Steilacoom Park are, from left to right, Cap Peterson, Charlie Peterson, Harold Carlson, and Rudy Tollefson. The park has baseball fields thanks to the Lakewood Rotary. Charlie Peterson was a builder by trade and baseball coach by passion. He died in March 1973. The Lakewood Rotary raised $12,000 to build baseball fields at Fort Steilacoom that bear his name to this day. (Courtesy of Lakewood Rotary.)

Springbrook Park
Jim McGranahan (standing at left), Ash White (standing at right), and Greg Rediske (kneeling) are pictured at Springbrook Park, which was built thanks to a $50,000 donation from the Lakewood Rotary. That area of town had no park space to speak of until the club stepped up. The club later committed more than $100,000 toward the building of a playground at Fort Steilacoom Park. (Courtesy of Lakewood Rotary.)

Al Stearns and Rotarians One of the most controversial members of the Lakewood Rotary was Al Stearns (far left). A pharmacist and owner of Clover Park Pharmacy, he donated a lot of his time to Rotary and helped aggressively recruit members. However, he also battled personal demons that tainted his time with the club, according to its published history. Stearns was convicted of issuing false prescriptions. (Courtesy of Lakewood Rotary.)

Rotarians
Shown here are, from left to right, (first row) Jim Rediske, Benni Andersen, Russ Klauser, and Al Hagen; (second row) Al Stearns, Carl Fynboe, Harold Gray, and Don Morris. The men are reportedly at a meeting related to the pancake breakfast at Clover Park High School, which remains a legendary fundraising event in the community. (Courtesy of Lakewood Rotary.)

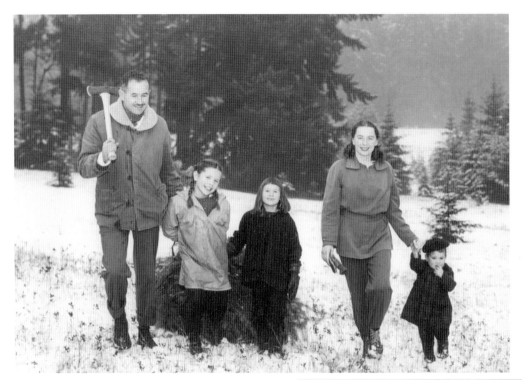

Chauncey Griggs

Shown here are, from left to right, lumber executive Chauncey Griggs; daughters Naomi and Tamar; his wife, Johanna; and son, Mark. They are returning from cutting a Christmas tree in 1948 on the Oakbrook property where Chauncey would later commission a home by Frank Lloyd Wright. The home still stands. Snow was nothing to the elder Griggs: among his accomplishments was helping to install the first rope tows west of New England at local ski resorts. (Courtesy of Tacoma Public Library.)

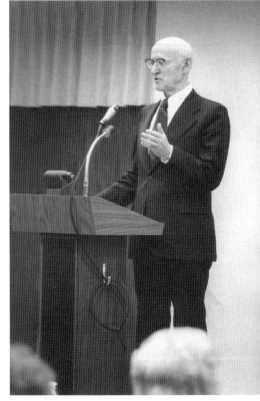

Herman Tenzler

Tenzler, president of the Northwest Door Co., speaks at an event at the Flora B. Tenzler Memorial Library, named for his late wife. It is because of Tenzler that there is a cross-section of a tree 13-feet in diameter in front of the library. The 586-year-old tree was cut on the company's timber holdings in Packwood in 1946. (Courtesy of Pierce County Library.)

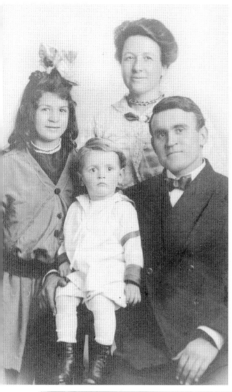

Holt Family

Lake City Church's origins begin in 1923 with a Sunday school organized by Welsh immigrant and lakefront homebuilder Joseph Holt, who donated the land for the building. Holt is seen here in 1918 with his wife, Mary; the future Janetta Lee, nine; and Marcus, two. The church community incorporated as the nondenominational Lake City Church in 1947. The church's slogan was "Fundamental and Friendly." Later named Lake City Community Church (hence the nickname LC3), the present building was completed in 1957. A youth center was built in 2005. (Courtesy of Diana Kirby.)

Stephen Bayne

Saint Mary's Episcopal Church formed modestly enough in the 1940s, when parishioners held services in a doctor's office. The church grew enough to buy the current site in 1949, holding services in a converted house before breaking ground in 1951 for the current church. The building has been modified and expanded to now include a school. Bishop Stephen Bayne had the honors of driving a surplus World War II Jeep fitted with a plow to break ground for the original building. (Courtesy of Saint Mary's Church and School.)

Samuel and Nathalie Brown
Samuel and Nathalie Brown gathered a group of parents and purchased 127 acres on Chambers Creek Road for a school, Charles Wright Academy, which opened with 40 boys on September 16, 1957. In September 1970, the academy admitted its first girls. Charles Wright now serves nearly 700 students in preschool through the 12th grade. The Browns remained active in supporting the school as well as their home church of St. Mary's in Lakewood until their deaths (Courtesy of Charles Wright Academy.)

M.E. Nesse
Reverend Nesse was the founding pastor of Christ Lutheran Church, serving from 1959 to 1977. Construction began on September 1, 1959, with funding from Trinity Lutheran Church in Moorehead, Minnesota. The contractor was Korsmo Brothers of Lakewood. Attendance was large for all services, as evidenced by the nursery being filled to capacity and three hours dedicated to Sunday school. The women's organization had six circles meeting regularly. Today, Christ Lutheran has over 700 members and offers three worship services, Sunday school, a vibrant confirmation and youth group, preschool, Latchkey, and Mothers of Preschoolers, as well as many other classes and fellowship groups. (Courtesy of Lyndi Reed/Christ Lutheran Church.)

Charles Hyde Kidnapping

Charles Hyde, who lived in Lakewood, was president of Tacoma-based West Coast Grocery, the largest grocery wholesaler in the Northwest and Alaska. He was a charter member of the Gravelly Lake Homeowners Association. His son and namesake was waiting for a school bus on Gravelly Lake Drive when a sedan pulled up. The boy was kidnapped. His father gave the kidnappers $45,000, and they released the boy. The kidnappers were later caught and sent to prison. Here, Pierce County sheriff Jack Berry is seen with 13-year-old Charles Hyde III in November 1965 as Charles tries to identify the car used to kidnap him. When he came to the station, the boy was dressed in gray slacks, a gray sport coat, and a tie. "That boy is sharp," the sheriff said. Charles eagerly cooperated with authorities. He attended Charles Wright Academy, where he was a goalie on the soccer team. (Courtesy of Walter Neary collection.)

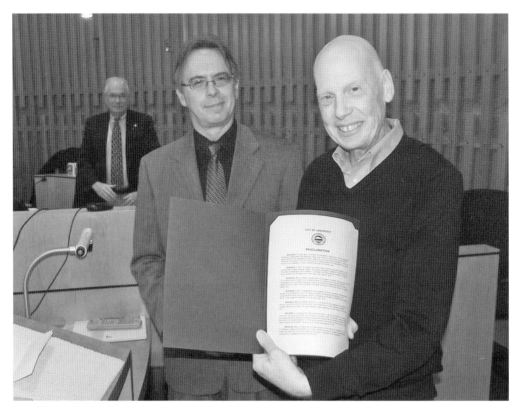

Marcus Walker

Marcus Walker has quietly and profoundly touched more lives than people can count as the most recent driving force behind Lakewood Players. Walker had already been a veteran actor in the Puget Sound area when he took the helm of the small theater in 2001. It had an annual budget of just $40,000. He helped grow the budget tenfold and start a large youth program. The critically acclaimed theater was hosting 14,000 people a year by the time Walker lost a very public fight with cancer in 2012. His courage under the almost certain death sentence was such that a Lakewood City Council proclamation reads, "If 'All the World's a Stage,' and thus all Lakewood a stage, among its most magnificent performers today is Marcus Walker." Walker is seen in the above photograph holding the proclamation, which was read by city councilman Walter Neary (left). City manager Andrew Neiditz stands in the background. Walker helped another community in a different way, as minister of Burton Community Church on Vashon Island. The stage and roadway in front of the Lakewood Playhouse have since been named in his honor, and a wall features a depiction of his smiling face (left). (Courtesy of Steve Dunkelberger.)

George Weyerhaeuser Jr.

George Weyerhaeuser Jr. is seen here in the lobby of his beloved Museum of Glass in Tacoma. Weyerhaeuser was an important advocate for the museum since its inception, serving on its board from 1999 and as chair from 2004 to 2007. The premature death of Weyerhaeuser at age 59 of a heart attack in April 2013 was a tragic day for Lakewood and beyond. He attended Charles Wright Academy for all his education until leaving for college. According to the family obituary, some of George Jr.'s favorite memories were of trips on his grandfather's boat, *Wanigan*. He and his father were the pilots and repair crew. This experience bonded him with his father and led to his love of figuring out how things work and solving problems.

George began his career at Weyerhaeuser in the woods as a contract logging supervisor and moved through the ranks, eventually holding a number of company posts, including vice president of manufacturing, president and CEO of Weyerhaeuser Canada, and senior vice president of technology. Part of his obituary reads: "From 2006 through 2008 he worked in Geneva, Switzerland, as a senior fellow to the World Business Council for Sustainable Development, combining his love of science, sustainability and policy-making. George reveled in the challenge of bringing together business, government and environmental groups to negotiate solutions to very complex problems."

Since 2008, he had cofounded two startups aimed at commercializing biotechnologies for improving sustainability in traditional pulp and paper industries. The obituary also said, "Throughout his career he had a keen interest in technology, sustainability, and scientific research. He greatly respected and cared for his coworkers. Many times people commented that, while working for George, they were able to say exactly what they thought, confident that they would be fully heard and understood.

"George loved time with family and friends, sunsets on the water, a glass of wine, and relaxing after a good day's work. Above everything else, George loved his family. He enjoyed his parents so much that periodically during his adulthood he moved back in with them for a month or more at a time (always for 'work reasons', of course)." (Photograph by Ken Emly; courtesy of Museum of Glass.)

Ken Emly

Weyerhaeusers
John Philip "Phil" Weyerhaeuser led the Weyerhaeuser Timber Company from 1933 to 1956, spanning the Great Depression and World War II. He is seen here with his wife, Helen, at their Thorne Lane home in 1954, two years before his death. (Courtesy of Tacoma Public Library.)

Weyerhaeuser Children

Phil Weyerhaeuser's children include George, who remains active with the company. He is seen in the below photograph with, from left to right, his son George H. Weyerhaeuser Jr., and sons Corydon Weyerhaeuser and Walker Weyerhaeuser. George Jr. is also seen at left with his wife, Kathy McGoldrick. They met while attending Yale. McGoldrick has served on the City of Lakewood's arts commission and was president of the board of directors of the Tacoma Art Museum during a period of significant expansion. During her time as chair, the museum negotiated for one of the most significant private collections of Western art unclaimed by a museum, and won it. Executive director Stephanie Stebich said that McGoldrick served "during a particularly exciting time, negotiating the Haub gift of Western American art and funds for new galleries and an endowment. She led the board in a transparent manner with great integrity calling special meetings to debate the possibilities and also challenges." (Left photograph by Sebastien Jacquy; below photograph by Sarah Weyerhaeuser, courtesy of Kathy McGoldrick.)

Milgards and Phillip

In the above photograph are Gary and Carol Milgard, who lived in a small house in Lakewood. They started a glass company, and Gary let his father and James, his brother, run that business while he set up shop as a window manufacturer. Today, Milgard Manufacturing is the largest supplier of residential windows in the Western United States. The business school at the University of Washington, Tacoma (UWT) bears his name. Below, Bill Philip and James Milgard are seen at the dedication of Philip Hall at UWT. William W. "Bill" Philip, another Lakewood resident, is best known for his leadership at Puget Sound National Bank and later at Columbia Bank, which he founded. Jim Milgard donated $2 million for the UWT assembly hall on the condition it was named in Philip's honor. (Above, courtesy of the Gary E. Milgard Family Foundation; below, courtesy of Jill Danseco/UWT.)

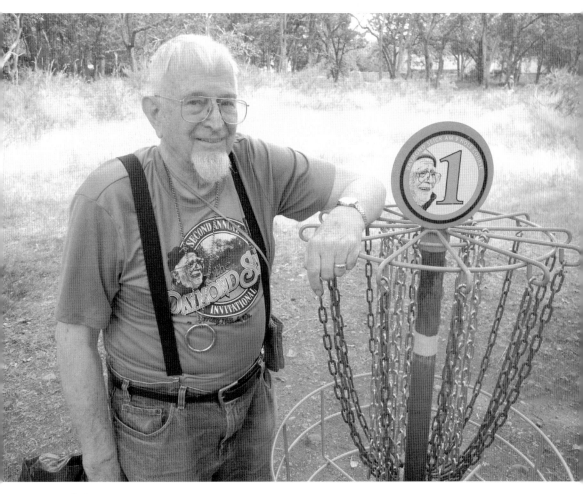

Ray Seick

Ray Seick just happened upon his place in history during a walk around Oakbrook in 1986. A volunteer effort to maintain a disc golf course on parkland was struggling. He volunteered to help and became the heart of what is now the Fort Steilacoom Disc Golf Club. The 45-hole course is nationally ranked, at one time in the top 10, largely because of Seick's efforts, including designing courses and mowing the lawns and pulling Scotch broom for four or five hours a day, every day, during the summer months to keep the course clear. The club is routinely used for tournaments by the Pro Disc Golf Association and is a destination for players from around the Pacific Northwest. There is now a memorial course named in Seick's honor. (Courtesy of Steve Dunkelberger.)

Lawrence Skinner

Dr. Lawrence Skinner impacted the medical community in the mid-1940s and helped provide medical care and minor surgery to the bedrooms of a community of farmers. His clinic started in a backwoods area in the Lakes District and became a state-of-the-art facility in just a few years.

The story of medical service in Lakewood started when the area had open fields, two-lane streets, and no traffic lights. Cows roamed the landscape. The date was 1946, and the area was slowly developing into Lakewood. Skinner's Lakewood Clinic was in a red brick medical office on Gravelly Lake Drive, across the street from Park Lodge. The location is now a bank. Skinner was also the Clover Park High School football medical trainer, sitting on the sidelines during games. He took care of patients throughout the week. Skinner answered calls night and day, rain or shine. Lakewood had no 911, ambulance response, or all-night emergency room.

The Lakes District relied on Skinner. He reportedly loved the work, but he also had bigger dreams. A 1958 article published in the *Sunday Ledger*, "Pioneer Surgeon and Physician in the Lakes District," outlined his dreams of modern and comprehensive medical treatments for his rural patients. That dream later became Lakewood General Hospital. The state-of-the-art building housed 110 beds and was featured in local newspaper stories during the planning and construction process. The nearly $2 million building at Bridgeport Way and 100th Street was dedicated on April 30, 1961. The nonprofit facility became the center of Lakewood. St. Clare Hospital bought the building, and it was abandoned in the late 1980s. The hospital served the Lakewood community for 28 years until it was replaced by a new hospital at 11315 Bridgeport Way in 1989. The property is now the Lakewood Pavilion. (Courtesy of Lakewood Historical Society.)

Dave Sclair

Sclair was publisher of the *Suburban Times*, the area's second newspaper, from 1975 to 1980. The paper took over from the tradition of the *Lakewood Log*. Sclair also published *General Aviation News*. A dynamo for Rotary, he was the force behind a playground in Fort Steilacoom Park that the community assembled somewhat like an old-fashioned barn raising. He is seen here standing at far right, unveiling a sign that shows the future park as his grandchildren come forward. (Courtesy of Ed Kane.)

Cy Happy

Cy Happy is Lakewood's first historian. The Lakewood native collected pictures and reminiscences from area families for many years. Here, he is holding a framed copy of the *Lakewood Log*, when its name was still incomplete. Publisher Charlie Mann held a contest to name the new paper in 1937. Mann chose *Log*, as in a ship's log. (Courtesy of Ed Kane.)

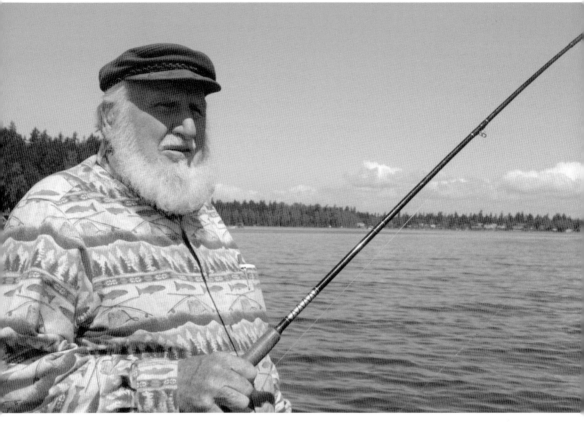

Glenn Anderson

The area now called Tillicum used to be called American Lake South. It was a destination for those who looked forward to recreation in and around the water. A float and diving tour was moved from the old Garrison's Resort in 1932 by Don Gawley, who hosted parties and fishing. Gawley sold his operation to Bill Merritt in 1945, and it became Bill's Boathouse. Glenn Anderson, pictured here, took over in 1971 and became a fishing legend, helping countless children and others experience fishing and the water. Anderson also restored old wooden boats. In 1995, writer Steve Dunkelberger, then of the *Lakewood Journal*, wrote, "If American Lake was salt water, Anderson would be a Steinbeck character." (Courtesy of Ed Kane.)

Basil Vyzis

Vassily "Basil" Demetrios Vyzis was one of the area's major real-estate developers and at one time a co-owner of the Frederick & Nelson department-store chain. He was best known as a pioneering developer of office and retail space in the Factoria-Eastgate area, which has grown to rival downtown Bellevue as a source of jobs. He was the driving force behind the transformation of Villa Plaza into what became Lakewood Mall, now Lakewood Towne Center. (Courtesy of the Lakewood Historical Society.)

Boo Han

Boo Han, pictured with his wife, Bang, came to Lakewood from South Korea in 1973 and began making tofu in a garage behind his house along Lakeview Avenue. The area had seen a boom in immigration from South Korea during the 1950s, when soldiers found themselves at Fort Lewis coming from the Korean conflict. But there was no International District back then. Lakewood can credit Han and his grocery and other businesses for that. The wreckage in the photograph reflects demolition that led to the expansion of the large center seen today. (Courtesy of the Han family.)

Elizabeth Poinsett and Becky Huber
Becky Huber (right), president of the Lakewood Historical Society (LHS) since 2006, poses with everyone's favorite docent, Elizabeth Poinsett. Huber, a retired Army major and RN, has been instrumental in keeping the society and its museum thriving. Poinsett, the daughter of Iva Alice Mann, one of the founders of the Clover Park School District, remained a lively part of LHS until she died in 2011 at age 100. (Courtesy of Becky Huber.)

Laurel Lemke
Laurel Lemke, who helped form Grave Concerns, is seen during a tour with Steve Dunkelberger, chair of the City of Lakewood Landmarks and Heritage Advisory Board and one of the founders of the Lakewood Historical Society. Grave Concerns looks after the Western State Hospital patient cemetery in Fort Steilacoom Park. The cemetery is the final resting place of 3,200 patients, whose graves are marked only by numbers, due to the stigma of mental illness at the time. Lemke worked with state senator Mike Carrell (see page 82) for legislation that allowed volunteers to replace the anonymous headstones with markers that have names. (Photograph by Kathryn Dunkelberger, courtesy of Kathryn Dunkelberger.)

Diane Formoso
Diane Formoso was driving a bus for the Clover Park School District when a kindergartener got on wearing his mother's high-heeled boots. He had no shoes of his own. While most people would have just thought about the situation, Formoso went from driver to driven. She formed Caring for Kids, an all-volunteer organization that has helped 3,000 kids in need, providing school supplies, clothing and shoes, food, hygiene products, and more. More information can be found at www.carekids.org. (Courtesy of Ed Kane.)

Grace Gius
The Lakewood First Lions Club has been one of the most active groups in Lakewood for years, thanks to members like Diane Formoso and several members of the city council. Another important person was Grace Gius (far right), seen here speaking from her familiar chair at Burs Restaurant. She was the first female president of the club, in 1992. The club had 33 members when she joined in 1972; it had more than 100 in later years. Gius would not let a resident rest until they were a Lion. She went to her own eternal rest in 2009 at age 91. (Courtesy of Ed Kane.)

Sen. Mike Carrell and Charlotte Carrell
In this 2004 photograph, 28th District state senator Mike Carrell (left) takes the oath of office. With him is his wife, Charlotte. Administering the oath is Justice Richard Sanders of the Washington State Supreme Court. Carrell, a high school science teacher before he ran for office, had a reputation for unleashing information about geology and other sciences during discussions at the state capitol. In the first of his 18 years as a lawmaker, in the House of Representatives, Carrell had a reputation as a barbed Republican who fought for better care of runaways and other causes. As a senator, he surprised people even in his own party with his insistence on working with and including Democrats in developing public policy. He was a great mentor to many lawmakers, including Walter Neary, one of the authors of this book. It was known that Carrell was battling cancer, but he insisted on remaining involved in the legislature. He won an unusual appropriation of $250,000, with the help of his successor, former representative and now senator Steve O'Ban, for preservation of deteriorating structures at Fort Steilacoom Museum. He also authored more than 10 new laws about mental health and ethics rules, among other subjects. Carrell died in office on May 29, 2013. At a memorial for Carrell, Washington governor Jay Inslee said, "He did as much during his illness as we do in our health." Carrell always closed his communications to constituents with the line, "It remains my honor to serve you in the Washington State Senate. " And it was an honor to know Mike Carrell. (Courtesy of Ed Kane.)

CHAPTER SIX

Cityhood

Public Service for a Community

The first Lakewood council members found themselves in a marathon. They had campaigned from April through September 1995 and then, after the election, met every Monday and Wednesday for three and a half to five hours a night, and sometimes on other days, before the city opened for business. They had to take approximately 300 votes to create the legal and policy infrastructure for a city of 60,000. And the council faced many more decisions when the city officially came to be on February 28, 1996, and was still negotiating contracts for police, parks, and road services. Starting a city from scratch was exhilarating. For many people, it was one of the most interesting things they had ever done, and something they would never want to do again. All sorts of strange things happened: for example, people started using the postal address "Lakewood" instead of "Tacoma," and some of the mail ended up in a community known as Lakewood north of Seattle.

The committee that had fought cityhood was no less interested in the community than anyone else. The Lakewood Citizens Against Incorporation donated $2,500 in unspent campaign funds to Greater Lakes Mental Health, the Lakewood Senior Center, and Historic Fort Steilacoom. "We do have the best interests of the Lakewood district at heart," the group's Bob Cowden said at the time.

Since the body had never existed before, the first city council had no incumbents, who normally enjoy an advantage in an election. With no such barrier, 48 people filed to run for seven positions. About 40 campaigned. A Korean American candidate lost in that first election in 1995; sadly, no Korean American has since run for the council.

It was a little-kept secret that the co-authors of this book and the *Lakewood Journal* had been forces to encourage incorporation. The independent voters of Lakewood, predominantly Libertarian, had been voting down incorporation since Clary Holm, Russell Garrison, and others first proposed cityhood in 1970. While the paper was always open to the voices against cityhood, it arrived every week at the homes of potential voters, detailing the problems that existed because of Lakewood's lack of local representation. Issues such as the plethora of strip clubs, abandoned buildings, and construction projects, including a jail and sewer line, advanced without proper notice to the public.

The following is a column that Neary wrote in a special section of the *Lakewood Journal* about cityhood. It helps to know two things: Lakewood had elected a city council before the official start of cityhood, so that planning could begin, and there had been a furious debate in recent weeks about a proposal to

allow housing and other development in Fort Steilacoom Park that had come from state senators Shirley Winsley and Lorraine Wojahn:

You could almost call it a touching moment. And to me, it was the final proof that cityhood was a good decision.

The hour was fast approaching midnight. The Lakewood City Council was getting a briefing from a county bureaucrat. Dick Dorsett works in the government relations division of Pierce County.

Dorsett's specialties include Fort Steilacoom Park. One of his jobs is to try to save the park from the state and possible development. And he has a deep file in his office of copies of documents that date back to the 19th Century.

Dorsett paused in the middle of his speech. He told council members that he was personally delighted to have someone to talk to about the park. He knew they would want to know about the park because the council members are from Lakewood.

That was a powerful moment for me, and it may have even helped to save the park. Here's why:

Let's imagine, for a moment, that there was no City Council. There would be no City Council because there would be no Lakewood. Dorsett would have no leaders from Lakewood to talk to. I might never have known about the bill to promote development of Fort Steilacoom Park. But you learned about it through our paper because there was a City Council for Dick Dorsett to meet with.

And as it turned out, the result of his briefing was an impressive sight. The people of Lakewood do not want out-of-towners mucking with their park. Your phone calls and letters set fire to the fannies of those state senators, and motivated your representatives to tackle the bill in the House.

All because Dick Dorsett had someone to talk to. All because you have chosen cityhood.

There have been a few rough times in the last few weeks. Some people took debates about taxes or business signs quite personally. There are times as a city when we individual pieces of the community will be very mad at each other. But we will still all be part of the city of Lakewood. The community of Lakewood. And we will be much better off than if we were not a city or community at all.

I reflected on all this on the weekend of Feb. 10 when something else happened. We gathered people in a mall lot for the cover photo of this section. I was afraid that no one would show up. But hundreds of people cared enough about Lakewood as a community to show up for a new city picture.

After the photo shoot, I drove to Fort Steilacoom Park for a stroll. I parked near the Lake Waughop lot, by the barns. As I got out, a couple, probably from out of town, was returning to their car. The woman looked at the rear bumper of my car and saw the sticker that says, "We love the city of Lakewood."

The news had not got to the visitor. She looked at her companion and asked him, "Is Lakewood a city now?"

And as I walked away, smiling, I thought about how we were saving the park and about all those people in the parking lot nearby. And I realized that I can answer that question. With certainty.

Yes, ma'am.

Lakewood is a city now.

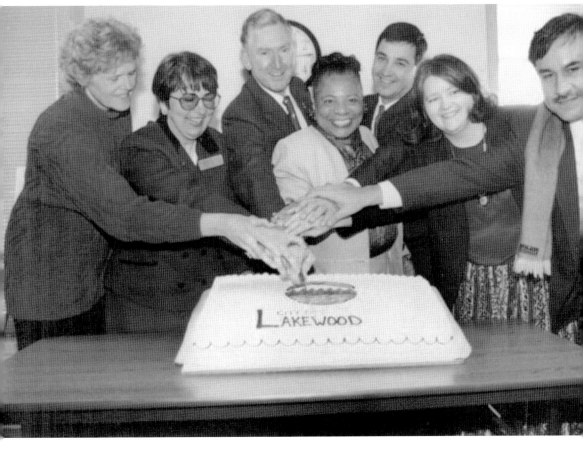

First Council
Members of the first council celebrate cityhood. They are, from left to right, Ann Kirk Davis, Colleen Henry, Mayor William Harrison, Deputy Mayor Claudia Thomas, Douglas Richardson, Sherri Thomas, and Jose Palmas. All were active in community activities before the City of Lakewood became official. They and subsequent city council members have needed the occasional sugar high to manage a busy and growing city. For example, the amount of park space the city has had to administer has grown from 36 acres at the start of the city to 400 acres. The number of peace officers protecting the city has nearly doubled. (Courtesy of City of Lakewood.)

Bill Harrison

Bill Harrison (see page 27) speaks at the dedication of the new Lakewood City Hall in 2003. Harrison is a retired lieutenant general, having commanded three posts, including what was then called Fort Lewis. Harrison had been a cochair with Andie Gernon of the cityhood campaign and was elected by his peers on the first council as presiding officer—the mayor—for the first eight years of cityhood. There was never any doubt he would be the first mayor. Harrison became the face of Lakewood to many people. The Clover Park School District honored him by naming their newest school the Lt. Gen. William H. Harrison Preparatory School. The City of Lakewood presents an annual Bill Harrison Volunteer of the Year award. At his retirement ceremony as mayor in January 2004, Harrison burst into tears as he thanked Madigan Army Medical Center for its fine treatment of his wife, Jo. Not everyone knew that by the time Harrison left his post, he was caring for his wife, who was suffering from an aggressive form of dementia. Bill Harrison is a model man on and off the political field. (Courtesy of Ed Kane.)

Scott Rohlfs

Rohlfs, seen above during his first week as the first Lakewood city manager, apparently enjoys reading the *Lakewood Journal* issue that discussed his arrival. The city offices were in donated space at the Lakewood Mall. The offices had garishly colored floor tiles because the space had previously been the Fun Factory, an activity center for children. Rohlfs had been a city manager at three cities, the most recent being SeaTac, before he took the Lakewood role. He retired in 2005. At right, he appreciates the police jacket that was presented to him to honor what was arguably one of the city's biggest accomplishments, establishment of its own police force in 2004. Before Rohlfs and the city established its own police department, the city had contracted with the county sheriff for protection. (Above, courtesy of City of Lakewood; right, courtesy of Ed Kane.)

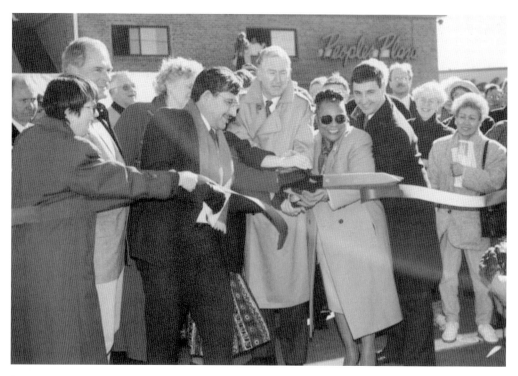

People's Plaza
City offices moved from the Fun Factory to People's Plaza at Bridgeport Way and Gravelly Lake Drive. The city had three phone lines, which quickly overflowed when the city began regulating businesses and signs, both hot-button subjects. The city had as many as 40 to 50 voicemails at a time. Cutting the ribbon are, from left to right, Colleen Henry, Lakewood Chamber of Commerce president Hugh Hedges, Ann Kirk Davis, Jose Palmas, Bill Harrison, Claudia Thomas, and Doug Richardson. (Courtesy of City of Lakewood.)

Court
One of the conveniences of the new city was that citizens no longer had to go to downtown Tacoma for many matters. John Feutz (left) was the city's original judge; the courtroom was named in memory of him in 2005. Bev Ferguson (right) was the original city courts administrator. (Courtesy of City of Lakewood.)

Alice Bush and Robert H. Benton Jr.
Lakewood city clerk Alice Bush, one of city government's first employees, enjoys the company of the oldest veteran in Lakewood—and one of the oldest in the nation—at the May 2003 dedication of the Lakewood Veterans Memorial at City Hall. Robert H. Benton Jr., 107, had attended the University of Washington before he decided to enlist in September 1917. After his training, Private Benton left for France and served with Company E, 1st Engineer Battalion, and saw combat beginning on September 12, 1918, at St. Mihiel-Loissone Salient, the first US offensive of World War I, and then at the Battle of the Argonne Forest. When Private Benton left the Army in December 1918, his discharge papers described his service as "Excellent."

In 1999, Benton was presented with France's National Order of the Legion of Honor, with the rank of chevalier, the highest distinction awarded by the nation. He was one of only eight World War I veterans living in Washington to receive the medal at the time. When this photograph was taken, Benton was living at the Veterans Affairs Hospital just outside city limits on American Lake. He died in September 2004. (Courtesy of Alice Bush.)

John Arbeeny, Ron Cronk, and Pad Finnigan
The original Lakewood city government and council were active in reshaping aspects of the town. As is common in new cities, a countermovement formed to encourage less government. Members of Lakewood CARES (Citizens for Accountability, Responsibility, Education and Service) served terms on the city council; here, they watch for election results in 2003. The three men standing at right are, from left to right, Ron Cronk, John Arbeeny, and Pad Finnigan. (Courtesy of Ed Kane.)

Glen Spieth and Richard Rabisa
These two "average citizens" have attended more Lakewood City Council meetings than many past and current members of the council. There were countless meetings when they and perhaps one or two others were the only citizens in the room besides council members and city employees. Seen here at the opening of the new city hall in 2003 are antiques storeowner Glen Spieth (left) and veteran and real-estate businessman Richard Rabisa, who came up with the name "Freedom Bridge" for an I-5 overpass to honor those serving overseas. (Courtesy of Ed Kane.)

Andie Gernon

Andie Gernon met and married Bill, her late husband, when they were attending the University of Chicago. He became a doctor. She majored in political science and hoped to run for office someday. Instead, she became known for bringing people together, whether it was other military spouses at Walter Reed Army Hospital or, later, at St. Frances Cabrini Church, the Lakewood Racquet Club, and Communities in Schools of Lakewood. Gernon attended a 1992 community summit on the many issues of Lakewood. It was there that a chain of events began that led to the cityhood campaigns. She cochaired the election committee that convinced voters in 1995 to approve cityhood. After the election, she chose not to run for council, but got involved in setting up ways for the city to help nonprofit groups. Gernon also became the coordinator of transition teams that helped the new council incorporate feedback from hundreds of citizens in starting the new city. "Andie Gernon is the epitome of a community volunteer, of the public-spirited citizen," Mayor Bill Harrison said in February 1996. "Her forte is getting people to work collaboratively—to work for a common goal." In 2003, the council appointed Gernon to a vacancy on the body, temporarily formalizing her longtime role as the "8th member" of the Lakewood City Council. She is seen here speaking to the council about why she sought the interim appointment. (Courtesy of Ed Kane.)

Claudia Thomas (ABOVE AND OPPOSITE PAGE)
Former city councilman John Arbeeny, who was instrumental in helping to make Claudia Thomas mayor in 2006 and 2007, cut to the chase in describing her: "She's in it for the kids." She and Andie Gernon cooperated as the council started to bring people together in a Human Services Collaboration that met regularly to discuss how citizens could work together to help the needy. Thomas was also one of the leaders who decided to set aside one percent of the city's general fund to give to nonprofit groups, thus giving the city not only a chance to support worthy causes, but the leverage needed to ask the groups to work together. Thomas also helped start the Lakewood Youth Council, where young people volunteer in the community and advise the city on issues. Thomas was elected by her peers as mayor for a two-year term, apparently the first African American woman in such a role. (Marilyn Strickland soon followed in nearby Tacoma.) In the top photograph on the opposite page, Thomas is seen with Mayor Bill Harrison's wife, Jo, at the annual Lakewood chamber chili cookoff. They became famous for what Thomas called Diversity Chili. Every council member made chili with their own recipe and all of it was mixed together in one pot. Longtime chamber director Linda Smith is at left. In the bottom photograph, Thomas represented Lakewood during a November 1–3, 2003, privately funded visit to its sister city in Japan, Okinawa City. She is dancing at the welcome ceremony with Ed Brewster, vice president of Pierce College (rear, left); his wife, Joan Brewster (center); and Ayumi Sakoda of Michigan, who was part of a cultural exchange program. (Above, courtesy of Ed Kane; opposite, both courtesy of the City of Lakewood.)

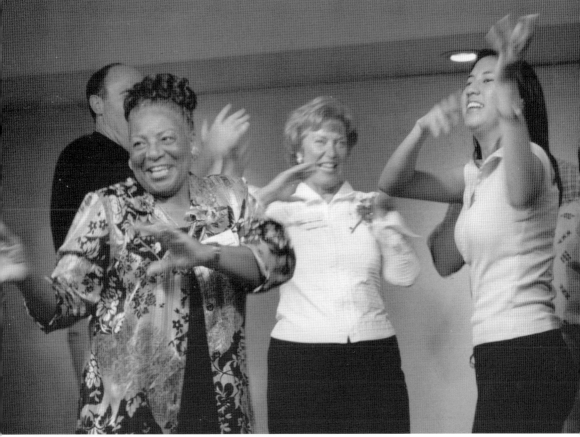

Helen McGovern-Pilant

Helen McGovern-Pilant, seen here with her husband, realtor George Pilant, was active in efforts for incorporation and later served eight years on the Lakewood City Council, including a stint as deputy mayor. Upon winning the nationwide Harlequin More Than Words award in 2012, she was described thusly:

> Two years ago Helen ended her successful career as a commercial realtor and public servant to transition into nonprofit human services. During these past two years, Helen has served as EFN's Executive Director, providing the fresh, energetic leadership and vision necessary to successfully guide the organization through this time of economic hardship. Although food insecurity is a difficult, persistent problem, Helen knows that our community holds the collaborative strength possible to provide vital hunger relief to those in need. Her work is proof that we can effectively tackle difficult problems like hunger and malnutrition through the goodwill of local businesses, schools, foundations, families, church groups, and friends in the community.
>
> Helen's story is inspirational, encouraging others to make similar career transitions into work that combines personal fulfillment and social impact. Helen is proof of the accomplishments and success that are possible when a person steps into a second career that puts their passion to work for the greater good.

She returned to the council in 2013 to fill the vacancy created by Doug Richardson's election to the county council. McGovern-Pilant, after a successful career in brokering real estate deals, is executive director of the Emergency Food Network. (Courtesy of Helen McGovern-Pilant.)

Larry Saunders and Andrew Neiditz
Lakewood police chief Larry Saunders (left) speaks at the ground breaking for the new Lakewood police station. With him is the city's second city manager, Andrew Neiditz. Saunders led efforts for community-based policing, in which officers get to know specific communities and try to identify small problems and challenges before they turn into big problems and crimes. Officers attend community meetings, along with other city employees. Saunders served 28 years in the Army and was a colonel in the military police before becoming Lakewood chief in 1998. He was at the helm when the city shifted from contracting with the county sheriff for police services to having an independent department. Neiditz became city manager in March 2005, leaving a similar role in Sumner. Neiditz, a former deputy Pierce County executive, has since become first executive director of South Sound 911, a unified dispatch and records agency. (Courtesy of Ed Kane.)

Doug Richardson

Lakewood formed its own police department in 2004. Here, Mayor Doug Richardson talks about the new department, flanked by officers. Richardson, an executive at Northrop Grumman, was chosen by his council peers as mayor from 2004 to 2005 and from 2008 to 2012. He was raised in West Groton, Massachusetts, and came to the Lakewood area while serving on active duty with the 2nd Ranger Battalion at Fort Lewis. He is a graduate of The Citadel in Charleston, South Carolina, and was awarded a masters in strategic studies from the US Army War College. Richardson retired from the Army Reserve as a brigadier general after completing 32 years of active and reserve service. He was awarded the Distinguished Service Medal. As mayor, he spearheaded the creation of the South Sound Military & Communities Partnership, which brought an unprecedented number of partners and interest groups together to address issues related to the military bases and the community (such as the infamous traffic). He left the council after an even larger segment of voters elected him to represent them on the county council. To the left of Richardson is Officer Tina Griswold, who, as the next chapter describes, unwillingly became part of the most historic chapter in Lakewood history. (Courtesy of Ed Kane.)

CHAPTER SEVEN

November 29, 2009

A World Mourns

The morning of November 29, 2009, had been a hard one. Several of the five Lakewood officers on duty had had to tackle a person who was either on drugs or mentally ill, or both. Officer Tina Griswold, 40, had been hit in the head. Sgt. Mark Renninger, 39, was the supervisor on duty. He and the others worked on the incident and paperwork until about 7:30 a.m. Then they drove to the Forza Coffee Shop at 11401 Steele Street South, in Parkland, just outside Lakewood city limits. No doubt they thought they could relax. Renninger bought himself a drink at 7:55 a.m. Griswold bought hers at 7:59. Officer Ronald "Ronnie" Owens, 39, bought his at 8:01. Officer Greg Richards, 42, was at the counter, still ordering or considering his purchase. One cannot be sure, as the security cameras inside the coffee shop were not working.

Griswold was eating a cinnamon roll as she waited for her coffee. She was four feet, 11 inches tall, but exceeded the fitness standard for both female and male officers. Renninger had his coffee and was eating an apple fritter. He was one of the state's top SWAT instructors.

The Forza chain of coffee shops had been founded by a former police officer. This particular location was handy to officers from many jurisdictions; it wasn't uncommon for state patrol officers, sheriffs, Tacoma police officers, and others to mingle there. If one had a list of public places a police officer should be safe, this would be at the top. Renninger and Owens had their computers open in front of them, no doubt working on more paperwork.

When people heard what happened next, many assumed that the lunatic had ties to Lakewood. Surely, he had been involved in altercations with Lakewood police, or perhaps had ties to the mental health offices in the area. No. He was just an insane criminal—the *Seattle Times* called him "240 pounds of muscle"—with a long record and facing a charge of child rape. He wanted to kill people in uniform. Sitting in a truck registered to his small business, he spotted the officers' cars outside the Forza. He entered the coffee shop, ignored the greeting of a barista, and walked to the tables where officers were sitting. He pulled out a 9-millimeter semiautomatic Glock and shot Griswold in the back of the head, killing her instantly. He then turned and shot Renninger in the right side of the head, killing him instantly. The gun jammed.

When Owens moved to stop the killer, the man produced a .38-caliber revolver and shot him in the head, killing him almost instantly. Richards struggled with him, and in the battle, the killer was shot in the stomach and Richards was shot in the head. The assailant then fled. Within a span of about 60 seconds, he'd murdered four of 102 Lakewood police officers: almost four percent of the workforce.

The official investigation of the crime and how it could have been prevented concluded: "We, as police, are in public places as a matter of routine. It is unrealistic to expect us to have guns drawn at every

member of the public who walks by. This incident was akin to a suicide bomber walking into a coffee shop and, without notice, detonating an explosive. The difference here is there were specific victims targeted and the suspect did not die in the attack."

There is of course much more to the crime. A manhunt was conducted before the perpetrator died two days later while confronting Seattle police.

The reader will notice that nowhere do the authors list the name of the man who shot the officers. That is because this is a book about legendary locals. His name is certainly public, but he is no legend. He had come from Arkansas, and there was much back-and-forth about whether he should have been free. Anyone interested in learning more on this subject may consult a book produced by members by the Seattle Times staff, The Other Side of Mercy.

This horrific event attracted the attention of the world. Prayers, cries, tears, and mementoes poured in from across the world. Jeff Brewster, the city's chief spokesman, would say later, "It certainly was a dramatic and traumatic event for the community. . . . It was Lakewood's mini 9/11. It galvanized us."

Twitter was two years old at this point, and the event, the hunt for the killer, and memorials related to the deaths also galvanized the world's social media community. City councilman Walter Neary, one of the first local elected officials to use social media to communicate with constituents, was among those who spotted all sorts of unusual memorial funds that were seeking contributions, some of them quite suspect. He and others in Lakewood encouraged people to stick to giving at one place, a fund set up by members of the police union. As it happened, one officer in the Lakewood Police Independent Guild was embezzling some of those funds. But enough money was raised to guarantee a college education and other benefits for the families of the four.

The pursuit of the killer became a lead item on social media platforms of the time. Locally, a minister who had served as a reserve officer for Lakewood police, Ken Witkoe, learned of the tragedy and immediately created a Facebook page "In memory and support of the slain Lakewood police officers," with a basic message: "Please pray! More later." The page attracted nearly 60,000 followers from as far away as Sweden and Australia and became a place to share official information and to hear from people about their reaction to the tragedy, connections to the four officers or other first responders, and other passionately shared thoughts and information. "I just did this as part of the grieving process; I never thought it would go anywhere," Witkoe later told the Association of Washington Cities. "I thought maybe a few friends of mine would have been interested, but 57,000? That's nearly the entire population of Lakewood. . . . When we were kids, this is the way neighborhoods would work. The Internet has made the world shrink."

In the winter of 2009, a shrinking world cried.

Readers will notice that most photographs of the fallen four officers are grainy. That is because the authors wanted to respect the privacy of family members and worked with the police department, which acknowledges that it used to take only very low-resolution pictures of its members. One of the sadder moments in the authors' research came while interviewing Assistant Police Chief Mike Zaro, who said, "One of the many things we do differently now is take more pictures of our officers."

If you think about that a moment, it's very sad.

Tina Griswold

Below, Officer Tina Griswold appears with other members of the school resource officers team in 2005. They are, from left to right, Griswold, Scott Young, Sgt. Keith Thuline, Gene Sievers, and Shirley McLamore. Before Griswold, 40, came to the original Lakewood force, she had been an officer for four years in Shelton and five years in Lacey. In Lacey, she was the only woman to serve on the force's tactical squad and to complete SWAT training. She had been on SWAT teams and was a member of Lakewood's Special Operations unit, targeting narcotics and vice. At the memorial service, one of her friends, Pamela Battersby, described Griswold as a caring mother and a dedicated, tough officer. "The fastest way to break up a bar fight was to throw Tina in the middle of it," Battersby said, bringing smiles to the crowd. She added, "What Tina most desired in her life was a close relationship with God, a clear purpose in life, a high degree of integrity and to be a good mother, wife and friend." (Both, courtesy of Lakewood Police Department.)

Ronnie Owens

Officer Ronald "Ronnie" Owens, 39, was the son of a Tacoma police sergeant and had played baseball in college. Standing six feet, three inches tall and weighing 200 pounds, he was a great athlete. The photograph below shows him playing one of the many games that were organized between police officers and firefighters to raise money for charity. He was a huge fan of NASCAR and motocross racing. Owens had served seven years with the Washington State Patrol, working I-5 in Seattle and then Tacoma before coming to Lakewood. At the memorial service, his sister Ronda LeFrancois said, "He was such a kind and gentle man. . . . Ronnie's greatest joy in life was being a father. He enjoyed spending every free moment he had with Maddie. She is Daddy's girl. I know how much he was looking forward to watching his daughter's first basketball games this season. I know Ronnie will be watching her every game from Heaven." (Both, courtesy of Lakewood Police Department.)

Mark Renninger
The photograph at left shows, from left to right, Rich Hall, Mark Renninger, and John Fraser being promoted as sergeants in 2008. Renninger, 39, had been an officer in Tukwila for eight years before he became one of Lakewood's originals. Renninger was an executive board member and instructor with the Washington State Tactical Officers Association. The leader of the Lakewood SWAT team, Renninger could have been the most experienced officer to confront the assailant, but he was killed at the start of the attack. At the memorial service, Lakewood assistant police chief Mike Zaro said, "We are left to always remember the man he was, follow the example he set, cherish the family and friends he left behind and I know that no matter where I am in my career, for years to come, I will always look for Mark's approval from the back of the room." (Both, courtesy of Lakewood Police Department.)

Greg Richards

Officer Greg Richards, 42, had most recently been a police officer in Kent before coming to Lakewood as an original member of the force. A native of California, he starting playing drums at age eight and never stopped. He enlisted in the Army in 1985 and served until 1989. Officer Richards hired on at the Kent Police Department in 2001 and joined the Lakewood force in 2004. "There weren't many things that he didn't like. In fact I can count them on one hand: disorganized drawers, mayonnaise and baggy pants. He said that you should dress and act in a way that shows you respect yourself and others around you," said son Austin, 17. Son Gavin, 10, told 20,000 people at the Tacoma Dome that his father would have been proud of the memorial service: "It shows us how strong the bond is between men and women in uniform and how wide it spreads, and we love you all because you all love him." (Both, courtesy of Lakewood Police Department.)

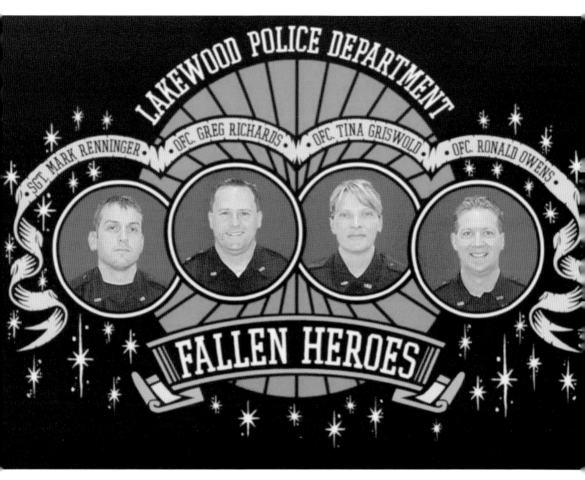

Everyman's Banner

Immediately after and for weeks later, gifts of all sorts flooded into the Lakewood Police Department from around the world. Many people responded with artwork. Most immediately, for the website and other documents, the department needed a way to mark that not one, but four people had been killed. A man in California emailed the department a version of this banner, inviting them to use it if they wanted to for any purpose. Officers liked the design and emailed the man sharper pictures of the officers; he responded with another graphic. This image was hung on a banner on the wall of the Tacoma Dome and was used by the department and others for websites and other memorials. The period was so chaotic that no one at the police department had any reason to ask for the man's name. They were just grateful. The authors of this book emailed the man in September 2013 to ask who he was and why he had created the banner. The artist responded that he preferred to remain anonymous. And he wrote the following, which pretty much sums up where Lakewood fit into the world at this time: "I was deeply affected by the tragedy in Lakewood. There are people all over the country and the world who have no direct connection to the officers or the town itself, and yet were profoundly moved. I sent the design simply because I wanted to offer a small, humble, anonymous gesture." (Courtesy of City of Lakewood.)

Memorial Service
At a memorial service nine days after the shootings, the Tacoma Dome was filled with law-enforcement officers and other first responders from around the country and beyond. The most colorful section belonged to more than 700 members of the Royal Canadian Mounted Police, which formed a small sea of red in their uniforms. Constable Chad Gravelle from Boston Bar, British Columbia, told the *News Tribune*, "I can't put it into words. . . . It could have been any of us." About 100 officers each came from Boston, New York, and Philadelphia. At the same time, it was well known that mentally unstable people and others could be attracted by such a gathering in one place for such a reason, and there were an unknown number of officers who honored the Fallen Four by standing as snipers on top of and around the Tacoma Dome. Other authorities from surrounding areas paid tribute by patrolling Lakewood during the service, allowing all surviving Lakewood police officers to attend the memorial. (Photograph by Weldon Wilson; courtesy of Lakewood Police Department.)

The Arch

As they near the Tacoma Dome, hearses pass under an arch created by the ladders of the Tacoma Fire and Lakewood Fire departments. The dead were honored by a 10-mile funerary procession comprised of over 2,000 vehicles representing nearly 400 agencies. The parade left a staging area on Joint Base Lewis-McChord and snaked for nearly four hours on a route past the Lakewood Police Department and then along South Tacoma Way. The parade included many cars from police agencies on the East Coast, including seven officers from Long Island, New York. "We had to show our support, not just for the department, but for the families," Nassau County officer Edward Jacobsen told the *News Tribune*. "Everything those officers were doing, we've all done and continue to do. A lot of us work nights. We drink coffee just to stay awake. Now you have to keep an eye open all the time. Both eyes really." Despite temperatures below freezing, citizens lined the parade route, waving flags, crying, saluting, and shouting encouragement and support. The *News Tribune* chronicled the story of Cindy Duncan and Joyce Michelsen, who set up chairs along Lakewood Drive Southwest and held signs that read, "God Bless You" and "Thank You." "When it started, we both started to cry," Duncan said. "It's just a wonderful thing to see, the way they've all come together. . . . It feels like we're a part of history, but it's a sad history." (Photograph by Weldon Wilson; courtesy of Lakewood Police Department.)

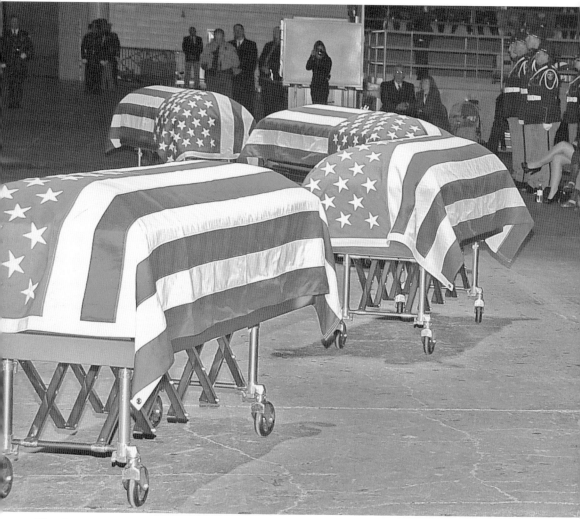

The Fallen Four

Bagpipers led the coffins of the four slain officers into the Tacoma Dome, and 20,000 people took a collective gulp. For many, the deaths of the officers became real when they were presented with the sight of four separate coffins. As each name was read, an honor guard of more than 70 law-enforcement officials genuflected in honor of the martyrs. At the end of the service, a voice called out for each one of the officers, followed by silence, followed by the words, "Gone but not forgotten." It was, as the

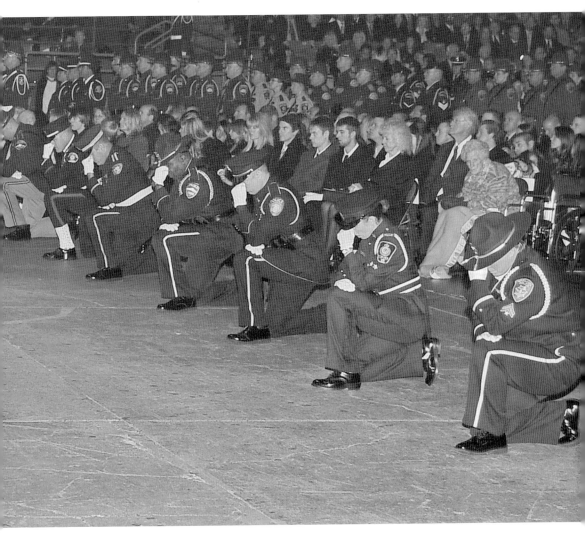

News Tribune put it, "a day unlike any other in Pierce County." "We will remember them today," said Gov. Chris Gregoire. "We will remember them always. . . . We will continue the cause of justice, and if in another time, another place, we meet those we honor today, we will be proud to tell them we kept our promise." (Photograph by Weldon Wilson; courtesy of Lakewood Police Department.)

Doug Richardson

"Today's ceremony is about honoring those lives and about honoring those sacrifices," Lakewood mayor Doug Richardson told the audience. "To an officer, they would tell you, 'On Nov. 29, I was doing my duty.' There is no higher calling than to do one's duty, and they served well." It was the most-quoted phrase from the memorial service as news of the event traveled around the world. Richardson served as mayor for several more years after the shooting and was later elected to the Pierce County Council. (Photograph by Weldon Wilson; courtesy of Lakewood Police Department.)

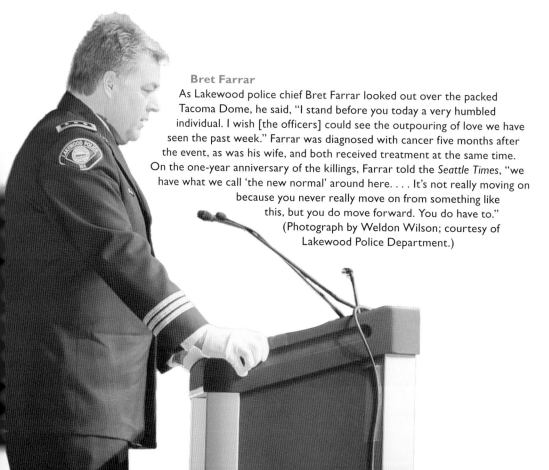

Bret Farrar

As Lakewood police chief Bret Farrar looked out over the packed Tacoma Dome, he said, "I stand before you today a very humbled individual. I wish [the officers] could see the outpouring of love we have seen the past week." Farrar was diagnosed with cancer five months after the event, as was his wife, and both received treatment at the same time. On the one-year anniversary of the killings, Farrar told the *Seattle Times*, "we have what we call 'the new normal' around here. . . . It's not really moving on because you never really move on from something like this, but you do move forward. You do have to." (Photograph by Weldon Wilson; courtesy of Lakewood Police Department.)

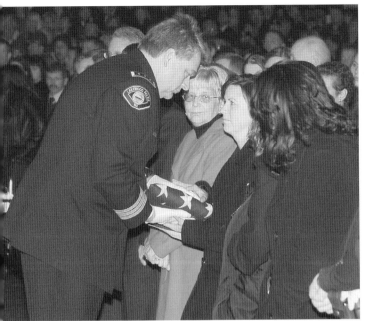

Kim Renninger
Lakewood police chief Bret Farrar presents a flag from the coffin of Sgt. Mark Renninger to his widow, Kim Renninger. The *Daily Mail* of England published a photograph of her carrying their three-year-old son Nicholas into the service. Nicholas spoke of his father two years later, telling KING-TV in Seattle, "He's in heaven." Nicholas helped to kick off an annual food drive held in honor of the officers by the Emergency Food Network of Pierce County. (Courtesy of Lakewood Police Department.)

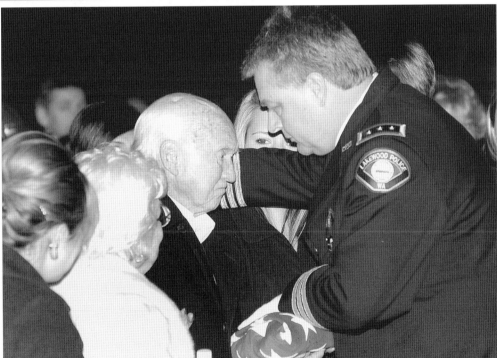

James Richards
Chief Farrar presents the flag that had adorned the coffin of Officer Greg Richards to his father, James Richards. After he graduated from high school, the younger Richards had entered the Army and was stationed at Joint Base Lewis-McChord. While stationed there, he received a Good Conduct Medal, the Humanitarian Service Award, and a Marksman's Badge. (Courtesy of Lakewood Police Department.)

The Richards Children
The children of Greg Richards, Gavin, 10; Jami-Mae, 15; and Austin, 17, took the stage at the Dome. Austin Richards said his father "never changed. He was born with a kind heart, courage and the drive to do what's right." Jami-Mae offered her father's recipe for happiness: "Cherish our loved ones' memories, laugh and enjoy the simple things in life every day. That's the secret." (Photograph by Weldon Wilson; courtesy of Lakewood Police Department.)

Gene Sievers
Officer Gene Sievers (see page 99), who had been a pallbearer for Richards, held members of the audience spellbound, if they weren't busy crying, by singing "The Dance." The song was written by Tony Arata and made legendary by performer Garth Brooks, who says the song honors those who die after a moment of glory for what they believe in. The music video includes footage of Martin Luther King Jr., John F. Kennedy, and the crew of the Space Shuttle *Challenger*. (Courtesy of Ed Kane.)

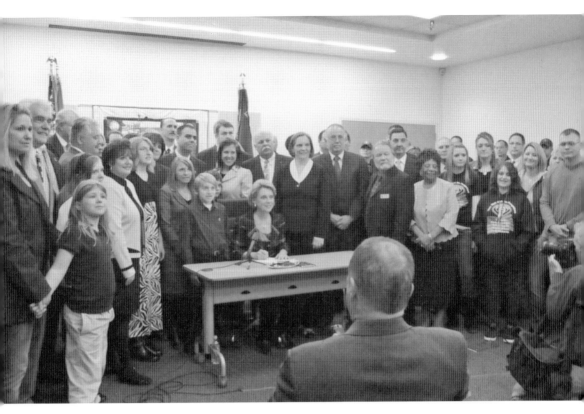

Governor Gregoire

There was considerable controversy about whether the assailant who killed the officers should have been on the streets. Confronted with the tragedy, state lawmakers passed several bills that sharpened laws and increased benefits for the survivors of police officers killed on duty. In March 2010, Gov. Chris Gregoire, seated at center, signed the bills into law. Among the people in this photograph are, to the left of Gregoire, Diane Owens, state senator Mike Carrell, Owens's daughter Madison, and Lakewood Police Guild president and officer Brian Wurts (two places to the left of the flagpole on the right). To the right of Gregoire are Rep. Tami Green (white collar), Officer Eric Bell, Lakewood City Council members Doug Richardson and Claudia Thomas, Jami-Mae Richards, Kelly Richards, Letra Renninger (one of Renninger's daughters), Officer Brian Markert, Melanie Burwell (Kelly Richards's sister), and Paul Griswold (Griswold's husband). (Courtesy of Lakewood Police Department.)

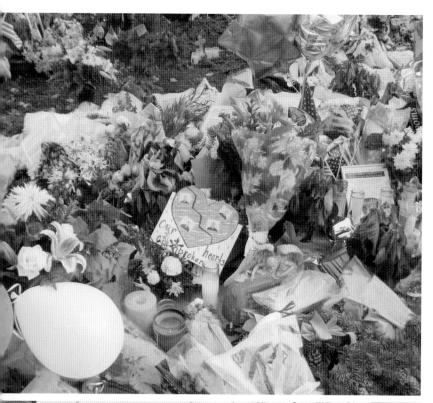

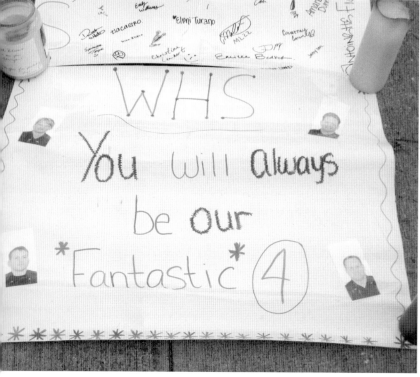

Memorial
Homemade memorials of all shapes and sizes flooded into Lakewood offices, and a shrine developed outside the police department. The poster shown below pretty much says it all, for now and for history. The department then found a way to move on. As Lakewood police chief Bret Farrar told the audience at the memorial service, "For these people right here. For Mark and for Tina and for Ronnie and Greg. We're going to strap our gear on, we're going to go back out there and we're going to protect our people. We have no fear, we will be careful, we will learn, but we will carry on." (Courtesy of Lakewood Police Department.)

CHAPTER EIGHT

Brushes with the Famous
Lakewood Rocks On

While the Pacific Northwest played a key role in the birth of rock 'n' roll more than half a century ago, few people know that Lakewood was the manger. Teenagers rocked out in basements and garages in the late 1950s and early 1960s, much like they did all around the nation. Three popular bands from the area played in Lakewood, honing their talents before scaling the musical mountaintops. The Fabulous Wailers played the rock classic "Louie Louie" in Lakewood before it reached national radio charts, later becoming a rock ballad and Washington State's unofficial song. The band's founding members attended Stadium High School, but they booked one of their first gigs at Lakewood's St. Mary's Episcopal Church in 1960. The Wailers' "Tall Cool One" earned the No. 36 spot on the national charts in 1959.

While Richard Berry had first recorded "Louie Louie" in 1957, it was the Wailers' single that became a radio hit. Other bands would cover the song and feed into its standing as an epic rock jam. The Kingsmen and Paul Revere & the Raiders recorded versions of the song in 1963.

Another interesting story that relates back to Lakewood involves the hall of fame band The Sonics, who drew their name from the McChord military base. Rock lore has it that a group of area teens were forming a band some 60 years ago. While they were contemplating a name, a jet from McChord Air Force Base flew overhead. The windows rattled from the plane's sonic boom, and the group had its name. The Sonics played the St. Mary's venue as well.

The history of The Fabulous Wailers and The Sonics has been immortalized in the film *Her Aim is True*, a documentary by Karen Whitehead about Jini Dellaccio's early days of photographing local bands in ways that revolutionized music photography and album design. It was a style that departed from staged photographs in controlled studios to live band shots and candid art designs that would capture the images of other up-and-coming bands, such as The Who, The Rolling Stones, and the Mamas and the Pappas.

The Fabulous Wailers and the Sonics are credited with inspiring many bands to this day. The Ventures, who also recorded a version of "Louie Louie," went on to the Rock and Roll Hall of Fame in 2008, adding yet another local link to the history of music. All three bands have displays at the Experience Music Project museum in Seattle. Washington lawmakers officially designated August 24 as "Louie Louie Day" in 2003. Often referred to as the unofficial rock song of the state, it is played during the seventh-inning stretch at each Seattle Mariners home game. The Fabulous Wailers and the Ventures cut a joint CD, *Two Car Garage*, in 2009 to mark the 50th anniversary of the founding of the groups.

Of course, Lakewood had several other brushes with history and famous residents who are both internationally known and locally remembered. These local ties have a lot to do with Lakewood being a melting pot of people sharing ideas and talents to better their community, as well as its varied collection

of attractions and natural beauties that bring the rich and famous to the area in search of escape from international spotlights and to leave their mark on a community they called home, at least for a time. Lakewood's location in the Pacific Northwest made it ideal for many in the spotlight to live relatively normal and anonymous lives while not making headlines. It is not uncommon to see television, movie, or music celebrities walking the aisles of local shops, pushing their grocery carts before jetting off to red carpets around the world.

The flow of military personnel into the community further added to the mix of notables. Yet others are local notables for darker reasons, either for what they did or what was done to them. Among them are Frances Farmer, a young actress on her way to stardom who was sidetracked by mental illness. Her story became a Hollywood legend well after her time in Lakewood.

Frances Farmer

Frances Farmer was Western State Hospital's most famous patient, an up-and-coming actress born in Seattle. The story surrounding her mental stability remains mysterious and full of contradictions. Farmer was called the screen's outstanding find of 1936 by film icon Cecil B. deMille, and Howard Hawks said she was the greatest actress he had ever worked with. Farmer was a contracted actress during Hollywood's golden age. Her career, however, was cut short by sporadic bouts of odd behavior that landed her in mental health hospitals. Her experiences there spurred books like *Shadowland* and her quasi-autobiography *Will There Really Be A Morning?*, and the movie *Frances* starring Jessica Lange. The Seattle band Nirvana had a song about her, "Frances Farmer Will Have Her Revenge on Seattle."

The accepted version is that Farmer was committed to Western State in 1944 during one of her episodes, which involved her attacking her mother. Farmer moved back in with her parents in West Seattle, but she and her mother fought bitterly. She spent three months at Western State and underwent electro-convulsive shock treatment and was deemed "completely cured." She was recommitted a year later and remained there for five years. There is much debate to this day about her treatment at Western State. Jeffrey Kauffman researched the records and medical files following her death in 1970. His exhaustive work, *Shedding Light on Shadowland*, takes apart the *Shadowland* book and other accounts. The must-read book sheds new light on what are widely known as "Farmer facts."

The Western State museum, which is mostly reserved for nursing students and targeted groups involved in mental health issues, has a room dedicated to Farmer and the debates surrounding her. (Courtesy of Western State Hospital.)

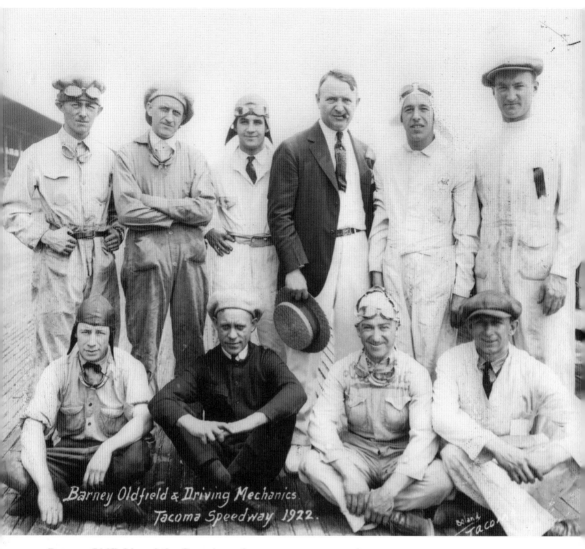

Barney Oldfield & Driving Mechanics
Tacoma Speedway 1922.

Barney Oldfield and the Speedway (ABOVE AND OPPOSITE PAGE)
In the 1910s and 1920s, the world's pioneers of auto racing came to the Tacoma Speedway, located on the grounds of today's Clover Park Technical College. A crowd of 40,000 rooted for their favorites. Above, racing pioneer Barney Oldfield (holding hat) poses with his crew in July 1922. The only others identified are Terry Curley (first row, left) and Harlan Fengler (second row, third from left). Fengler would become chief steward of the Indianapolis Motor Speedway from 1958 to 1974. Note that the men are standing on wood boards, which seemed like a good idea for a racetrack at the time. At right, Chicago millionaire racer Joe Boyer Jr. poses before a July 5, 1920, 225-mile race. The world-class competition included Ralph Mulford, Cliff Durant, Eddie Hearne, Indy 500 winner Gaston Chevrolet, Roscoe Sarles, and Tommy Milton. The participants were competing for a total purse of $22,500. Milton and his Duesenberg took first in a record time of 2 hours, 23 minutes, and 28 seconds, averaging 95 miles per hour. Boyer was out in the 97th lap with a broken wrist pin. The next year, Milton became the first two-time winner of the Indy 500. (Courtesy of Tacoma Public Library.)

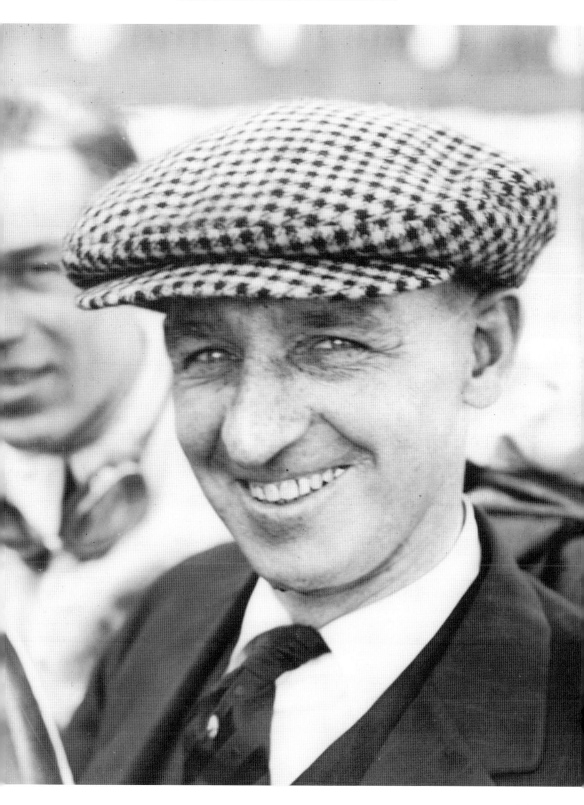

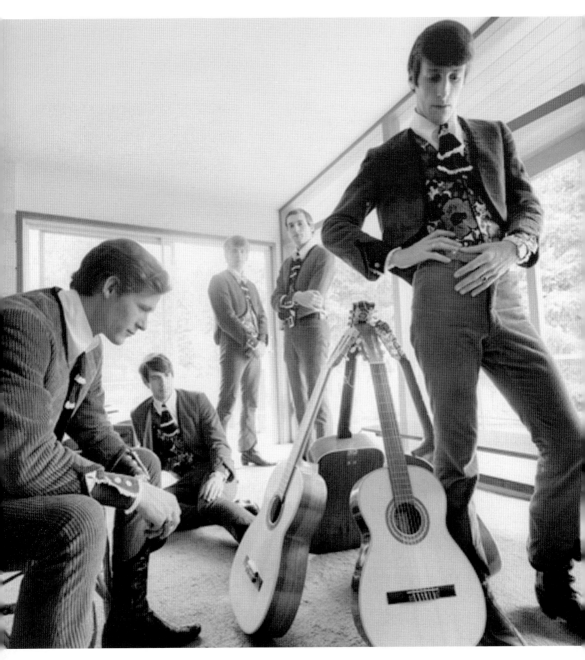

The Sonics
The Sonics lineup in this 1966 image included, from left to right, Larry Parypa on lead guitar and vocals; Gerry Roslie on organ; Andy Parypa on bass; Rob Lind on saxophone, vocals, and harmonica; and Bob Bennett on drums. The lyrics of The Sonics' original material dealt with early 1960s teenage culture—cars, guitars, surfing, and girls—and played well on local airwaves before they were "discovered" by the rest of the nation and eventually memorialized at the Rock and Roll Museum in Seattle. (Courtesy of Jini Dellaccio Collection, 4616 25th Avenue NE, PMB 770, Seattle, WA, 206-459-0983, www.jinidellaccio.com. © Jini Dellaccio Collection. All rights reserved.)

The Fabulous Wailers

The Fabulous Wailers began as The Nitecaps in 1958. In this 1968 photograph are, from left to right, John "Buck" Ormsby on guitar, Rod Gardner on sax, Dave Roland on drums, Denny Weaver on guitar, and Kent Morrill on keyboards and vocals. An earlier version of the band included many notables in the local music scene, including John Greek on rhythm guitar and trumpet, Mike Burk on drums, and Rockin' Robin Roberts, who played with the band from 1958 to 1960. Ormsby, Morrill, and Roberts then formed Etiquette Records; in 1961, the label released its first single, a cover version of Richard Berry's "Louie, Louie," and the rest was rock history with the lineup of Morrill, Ormsby, Richard Dangel, Burk, Mark Marush, and Roberts. Ormsby remains active in promoting music in education and was a driving force behind "Louiefest," a celebration of local rock history and the appreciation of the state's role in rock history. (Courtesy of Jini Dellaccio Collection, 4616 25th Avenue NE, PMB 770, Seattle, WA, 206-459-0983, www.jinidellaccio.com. © Jini Dellaccio Collection. All rights reserved.)

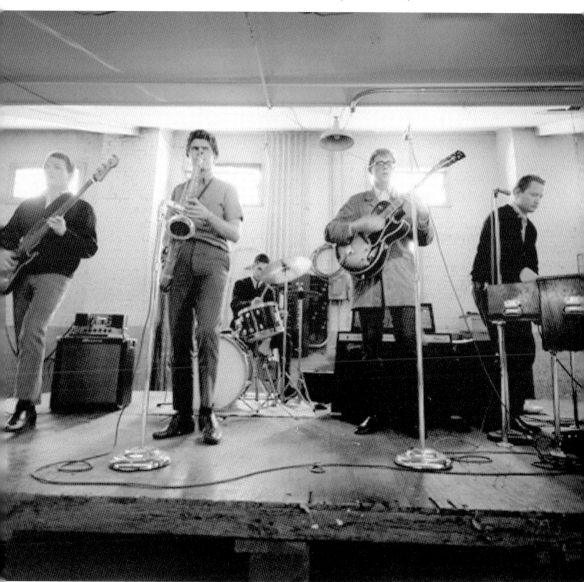

Harold Bromley

Harold Bromley was a pioneer of aviation who was set to be a national hero, had he succeeded. However, he lost out to one of his counterparts, Charles Lindbergh. Bromley had repeatedly attempted to make the first nonstop flight between the Pacific Coast and Japan, but failed each time. He began his flights in his Lockheed Vega from the airstrip in present-day Lakewood. He first attempted the trans-Pacific flight in July 1929, two years after Lindbergh crossed the Atlantic. The challenge was the "next big feat" in aviation.

Born Albert Harold Bromley on November 10, 1898, in Victoria, British Columbia, he enlisted in the Canadian army and served three years as a machine-gunner in World War I. He then joined a Canadian unit of Britain's Royal Air Force in the waning days of the war. Bromley then settled in Olympia and operated a flying school in the Lakes District in the 1920s and flew as a test pilot for Lockheed in Burbank, California. Among his students were Amelia Earhart and Jimmy Doolittle, whom Bromley familiarized with the Vega monoplane. Not content to train others, Bromley persuaded businessmen in Tacoma to raise $25,000 to buy a single-engine, low-winged monoplane in which he hoped to fly nonstop to Tokyo. Tacoma had no airport, but residents approved a $300,000 bond to build an airstrip. They also bought a gold watch that Bromley was to present to the emperor of Japan on behalf of the city. In this photograph, US Navy lieutenant P. Weems (left) shows Bromley how to use a bubble sextant for an upcoming attempt.

Some 70,000 spectators visited the airfield, on what is now Clover Park Technical College, to watch Bromley start up the engines of his orange Vega, named *The City of Tacoma*, at 6:00 a.m. on July 28, 1929. Bromley headed down the runway, but his overfilled fuel tanks spilled gasoline on the windshield. He leaned out of the cockpit to get a better view and caught some fuel on his flight goggles. He took them off, only to have gasoline spray into his eyes. The plane swerved off the runway and was damaged. He tried again in September, when he attempted to take flight from a Burbank runway. However, he crashed into a street. Bromley then decided to try crossing the Pacific from Japan, to take advantage of tail winds. He abandoned his dream of a solo flight, hiring a skilled navigator and radio operator, Harold Gatty, to fly with him. He bought a single-engine, high-wing monoplane built by Emsco Aircraft of Downey, California. The plane, also called *The City of Tacoma*, was shipped to Tokyo aboard a steamship. The two men flew almost 25 hours and made it halfway to the Aleutians before they were forced to return to Japan because of bad weather and gas fumes in the cockpit.

Bromley gave up on the record-setting effort and spent the next few years flying mail planes from El Paso to Mexico City. He then served as a federal aviation inspector at the Oakland airport. He died on December 2, 1998, at a nursing home near his home in Palm Desert, California. He was 99. News of his death made the *New York Times*. (Courtesy of Walter Neary.)

JZ Knight

In the late 1970s, a cable company marketing executive, JZ Knight, moved with her two boys to Lakewood in order to be centrally located within Puget Sound. She married a local dentist and later wrote that she experienced unusual events, such as a miraculous healing. In her Lakewood kitchen one day, she wrote, Ramtha appeared. The Ramtha's School of Enlightenment describes him in this way: "Ramtha lived as a human being 35,000 years ago on the ancient continent of Lemuria. The Lemurian culture was highly spiritual. Due to dramatic Earth changes, many Lemurians migrated from what is now the U.S. Pacific Northwest through Mexico into the Atlantic basin (then Atlantis)." Knight, Ramtha's channeler, wrote in her book, *Ramtha*, that she received many other visits from him, including in the Lakewood Safeway. She later moved to Yelm in order to have a large horse ranch. (Courtesy of Walter Neary.)

Linda Evans

Evans, the American actress best known for her role as Krystle Carrington in the 1980s drama *Dynasty*, was born on November 18, 1942, with the family name Evenstad. She gained her first taste of fame playing Audra Barkley in the 1960s Western television series *The Big Valley*. After two marriages, Evans began a relationship in 1989 with new-age musician Yanni that lasted 10 years. The couple maintained a $1.7 million house in Lakewood's Madera neighborhood during that time. Evans was diagnosed with idiopathic edema and began investigating alternative healing methods. This led her to the metaphysical teacher JZ Knight and her Ramtha's School of Enlightenment, which had a compound in Yelm.

Evans has a star on the Hollywood Walk of Fame, at 6834 Hollywood Boulevard. When she decided to sell her Lakewood home in 2007, John Sparling and his crew were the first filmmakers given access to it. The footage is still available on youtube.com. (Courtesy of Linda Evans.)

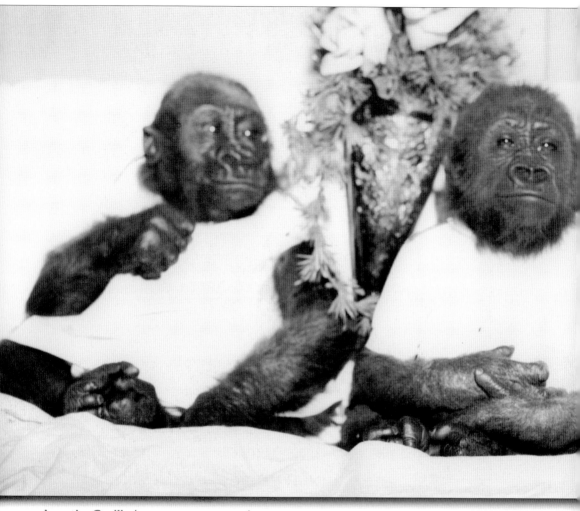

Ivan the Gorilla (ABOVE AND OPPOSITE PAGE)
Baby Ivan showed up from the Congo cute as a button, though a big button. He is seen above with another baby, Burma, in August 1964 shortly after arriving in Tacoma. The gorillas were purchased by E.L. Irwin, the owner of the B&I Circus Store at 8012 South Tacoma Way. Burma died soon after arrival. Ivan lived at the Irwin home, doing such eye-catching things as joining the family for visits to the dentist. Soon, his growing size and energy meant he had to move into a gorilla house at B&I, where he stayed nearly 30 years even while other tourist attractions died off and he became the lone animal there. The authors remember visiting the shopping center and talking to people about Ivan, only to jump when the gorilla would leap from one end of the complex to the other, apparently enjoying startling people. He would also watch a black-and-white television. A 1991 documentary alerted the nation to his situation, and people around the world protested that this was not a natural situation for a gorilla. In 1994, Irwin's family let him go to the zoo in Atlanta. In an event at B&I, people signed cards for Ivan and shared memories of an innocent childhood and a different world. Ivan lived the rest of his life in the company of other gorillas. He died at age 50 in 2012. (Above, courtesy of Tacoma Public Library; opposite, both courtesy of Zoo Atlanta.)

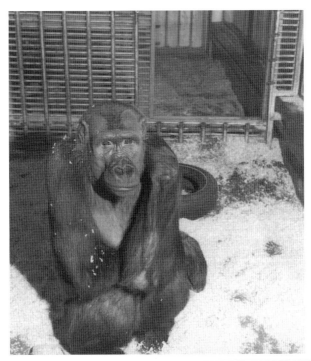

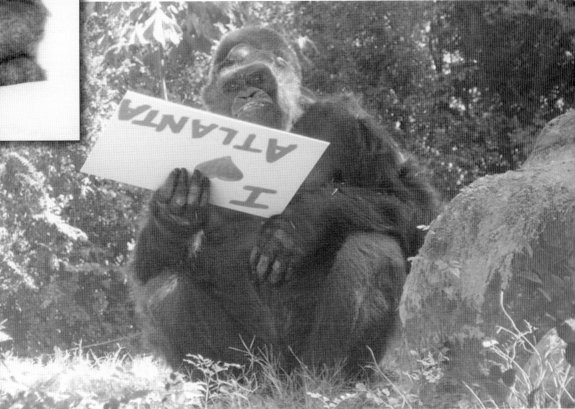

Majalisa Benson
Prince Bertil of Sweden enjoys the plethora of Swedish dishes at the Viking Smorgasbord, 9702 South Tacoma Way in Lakewood, on May 14, 1958. According to the Tacoma Public Library, the menu included *silsalat* (herring salad), *koldomar* (meat wrapped in cabbage leaf), *lax* (smoked and salted salmon flakes), *inlagt sil* (herring), and Swedish meatballs. With the prince is believed to be the restaurant's owner, Majalisa Benson, originally from Sweden. Prince Bertil devoured the food in a flat seven minutes, remarking, "My only regret is that the plates are not large enough." He had arrived in the United States days before, with his primary purpose to participate in ceremonies honoring the 100th anniversary of Minnesota's admission to the Union. (Courtesy of Tacoma Public Library.)

Ferdinand "Jelly Roll" Morton
Some of Lakewood's history is unrecorded, because few people have written about experiences in brothels. In fact, brothels outside the area of Camp Lewis do have a history, the most famous piece of which involves jazz pioneer "Jelly Roll" Morton. According to Seattle jazz historian Paul de Barros, Morton was involved in a tavern and brothel outside the base in the Ponders area. That is part of the area's musical history. Fort Lewis brought diversity to Lakewood, so jazz flourished during and after World War I on the installation. Musicians who left military service often moved to the more diverse Seattle and helped establish a thriving jazz scene there. (Courtesy of Walter Neary.)

Robert Cray

Robert Cray, a multiple Grammy Award winner, got inspiration for his blues career while attending the 1971 graduation party at Lakes High School. He was sitting next to Bobby Murray when Albert Collins performed. "I was sitting right next to Robert and our jaws just dropped," Murray told the site *JB Blues*. "I knew right then and there that was what I wanted to do. It changed Robert too. It was great because we were both able to continue a relationship with Albert until he passed away [in 1993]." The son of an Army quartermaster would go on to form Steakface with Murray, known as the "best Lakewood band you have never heard of." Cray graduated to a solo career that has spanned 40 years. He won his first Grammy Award for the album *Strong Persuader*. The single "Smokin' Gun" attracted considerable attention. Cray is considered one of the best blues guitarists, period. In 2011, he was elected to the Blues Hall of Fame. (Courtesy of Robert Cray/Music One Live.)

INDEX